Great Lakes Indian Art

Great Lakes Indian Art

Edited by David W. Penney

WAYNE STATE UNIVERSITY PRESS
and the DETROIT INSTITUTE OF ARTS
Detroit 1989

Contributors

Julia Harrison is Curator of Ethnology, Glenbow Museum, Calgary Alberta.

Nancy Oestreich Lurie is Curator of Anthropology, Milwaukee Public Museum, Milwaukee.

Evan M. Mauer is Director of the University of Michigan Museum of Art and Professor, Department of the History of Art, Ann Arbor, Michigan.

David W. Penney is Associate Curator, Department of African, Oceanic, and New World Cultures, the Detroit Institute of Arts.

Ruth Bliss Phillips is Associate Professor of Art History, Carlton University, Ottawa.

Richard A. Pohrt is a collector of Native American Art who lives in Flint, Michigan.

Janet Stouffer served as an intern in the Department of African, Oceanic, and New World Cultures, the Detroit Institute of Arts.

Portions of this volume originally appeared as the *Bulletin of the Detroit Institute of Arts*, Volume 62, Number 1, 1986. Copyright © 1989 by Wayne State University Press, Detroit, Michigan 48202. All rights are reserved. No part of this book may be reproduced without formal permission.
93 92 91 90 89 5 4 3 2 1

Library of Congress Cataloging-in-Publication Data

Great Lakes Indian art / edited by David W. Penney.
 p. cm.
 "First appeared as a special issue of the Bulletin of the Detroit
Institute of Arts (vol. 62, no. 1, 1986) devoted to the museum's
Chandler/Pohrt collection of Native American art"—Foreword.
 Includes bibliographies and index.
 Contents: Great Lakes Indian art: an introduction / by David W.
Penney—Representational and symbolic forms in Great Lakes-area
wooden sculpture / by Evan M. Maurer—Horse imagery in Native
American art / by David W. Penney and Janet Stouffer—Dreams and
designs: iconographic problems in Great Lakes twined bags / by Ruth
Bliss Phillips—Beaded twined bags of the Great Lakes Indians / by
Nancy Oestreich Lurie—"He heard something laugh": otter imagery
in the Midéwiwin / by Julia Harrison—Pipe tomahawks from Michigan
and the Great Lakes area / by Richard A. Pohrt.
 ISBN 0-8143-1970-X. ISBN 0-8143-1971-8 (pbk.)
 1. Indians of North America—Great Lakes Region—Art.
2. Chandler, Milford G., 1889-1981—Art collections. 3. Pohrt,
Richard A., 1911- —Art collections. 4. Detroit Institute of
Arts. I. Penney, David W. II. Detroit Institute of Arts.
E78.G7G74 1989
709'.01'10977—dc19

87-36857
CIP

Director of Photography, Detroit Institute of Arts: Dirk Bakker

Unless otherwise indicated, all objects illustrated are in the collection of the Detroit Institute of Arts.

Front cover: *Pipe Tomahawk.* See p. 94.

Back cover: *Midé Bag.* See p. 82.

Contents

Foreword

The essays in *Great Lakes Indian Art* first appeared as a special issue of the *Bulletin of the Detroit Institute of Arts* (Vol. 62, No. 1, 1986) devoted to the museum's Chandler/Pohrt collection of Native American art. This outstanding group of over 600 objects has few equals in the completeness of its representation of Native American art of the Great Lakes area and in the high aesthetic quality of each object. The acquisition by the Detroit Institute of Arts of this collection fit the overall mission for the institution: to display the greatest works of art created at any place and in any time. In the late 1970s when Frederick J. Cummings was director, we heard that Richard J. Pohrt was seeking a permanent home for the Chandler/Pohrt Collection. Mr. Pohrt credits Boris Sellers, former director of the Founders Society, as the architect of the plan that eventually secured the collection for the museum, with the generous assistance of Henry Ford II, the Flint Ink Corporation, the Flint family, and Richard Manoogian. In 1980 the Eula B. and H. Howard Flint Gallery of Native American Art opened at the museum and here the magnificent Chandler/Pohrt collection joins other works of art to be appreciated by the public. This is also an appropriate time to acknowledge the contributions of Mr. and Mrs. Peter W. Stroh, the Stroh Brewery Foundation, and the Dabco/Frank American Indian Art Fund. Our thanks go to all these donors for their generous support in developing this significant portion of our collection devoted to Native American Art.

Under the direction of David Penney, Associate Curator of African, Oceanic, and New World Cultures, a series of programs was developed in 1982 to introduce the Chandler/Pohrt collection to scholars and the public. The authors of the essays in this volume were aided in their study of the collection by a grant from the National Endowment for the Arts, a federal agency. We acknowledge with gratitude the efforts of the Detroit Indian Center and Southeastern Michigan Indians, Inc.; we also particularly wish to thank Linda Laroque and Dr. Thomas Volk. Members of the museum staff whose professional assistance with this publication should be recognized are Dirk Bakker, Director of Photography, and members of that department; Julia Henshaw, Director of Publications, and Judith A. Ruskin, Assistant Editor. Without the support of Dr. Robert Mandel, Director, Wayne State University Press, this publication in its present form would not have been possible.

Michael Kan
Deputy Director, the Detroit Institute of Arts, and Curator of African, Oceanic, and New World Cultures

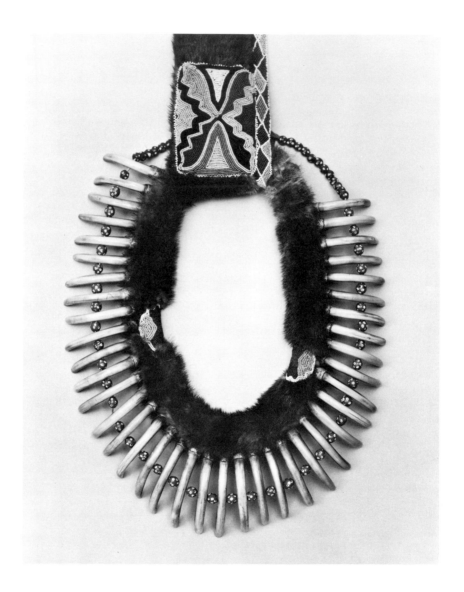

Figure 1.
Bear Claw Necklace
(detail), Sauk and Fox
(Tama, Iowa), c. 1835;
bear claws, fur, glass
beads, ribbon, horsehair,
and cloth, 44.5 x 36.8 cm
(17½ x 14¼ in.).
Founders Society
Purchase with funds
from Flint Ink
Corporation (81.644).

Great Lakes Indian Art: An Introduction

David W. Penney

Popular understanding often divides Native North American culture into two conceptual epochs, the traditional past and the highly acculturated present. This perception stems from a simplistic misunderstanding of the effects of an important episode in Native American history, the discovery and settlement of the New World by Europeans. Traditional Native American life prior to the arrival of Europeans is often considered a stable, golden age. Post-contact Native American history is interpreted as an era of cultural erosion in which traditional practices and beliefs were gradually and irrevocably lost or transformed. Such a division between "traditional" and "acculturated" creates a false impression of both pre-contact and post-contact Indian life. It presupposes an idealized time of traditional life which was static and unchanging and precludes any progress or synthesis in the Native American response to European culture by shading post-contact history in negative terms of decline. Both the 15,000 year history of North America prior to the arrival of Europeans and the 500 years since witnessed active episodes of Native American cultural change that defy easy generalization. This history can be documented by a record of manufactured objects, artifacts recovered through archeological excavation, or preserved by collectors from the hands of the people who made and used them. Complex objects, those that by their design, function, and esthetic intent convey a great deal of information, can be analyzed successfully through the methods of art history. There is no indigenous term for art, but the European-American word can be adapted to convey Native American means of visual expression, often manifested through the practice of making things, be they costume, ornament, weapon, utensil, or sacred object. One of the most remarkable aspects of the historic record of Native American art is the degree to which it reflects the quick pace of post-contact cultural change with continuous technical and esthetic innovation. Rather than suffering artistic decline, as might be predicted when post-contact history is characterized as a period of irrevocable loss of traditional life, Native American artists invented new techniques and explored novel means of expression that responded to profound changes in lifestyles and material circumstance. The essays in this volume demonstrate the various ways in which objects can be used to inform us about Native American history of the post-contact era.[1]

The early collections

The early penetration of the Northeast and the Great Lakes region by the French and the subsequent geographical importance of the area to Britain and the United States provided particularly rich collections preserved to the present day. The region was inhabited by the members of two large Native American language families: Iroquoian speakers of New York state and southern Ontario and Algonkian speakers to the north and west. The latter were bordered by Siouan speakers in the westernmost area of the Great Lakes region. The earliest broad overview of Native American art of the historic period stems from collections assembled during the eighteenth century by French and British military men, traders, and even tourists who traveled among the settlements and military posts established throughout the Great Lakes region.[2] Early collections tend to consist of small, portable objects of embellished costume—moccasins, small pouches and bags, sashes, and garters—and utensils of everyday life such as spoons, pipes, weapons, and woven burden straps. These objects, together with contempo-

9

rary descriptions, provide a fairly accurate and comprehensive picture of the arts and industries of eighteenth-century Great Lakes Indians.

Most items of clothing, such as moccasins, shirts, dresses, leggings, and bags with straps that substituted for pockets were made of deerskin blackened with a stain derived from boiling the hulls of black walnuts. These items were often subtly decorated with designs embroidered with porcupine quills colored with vegetable, mineral, and later, commercial dyes. A small rectangular *Bag* (fig. 2) made of blackened deerskin is representative of a type of pouch found among several early collections. On this bag three different varieties of porcupine quill embroidery were employed to produce patterns and designs. Three rows of "zigzag band" quillwork above the opening of the pouch and one row below create oblong panels filled with alternating bars of white, red, green, and black. These simple geometric patterns contrast with the pictographic representation in the center of the bag portraying the mythic Underwater Panther. This design was created with a "simple-line" technique in which

individual quills were twisted around a sinew foundation and stitched down at regular intervals to produce a continuous, linear element with which the artist could create a design. The oblong panels of zigzag bands above the Underwater Panther are also outlined in simple line technique. Finally, the entire bag is bordered by a technique known as "single-quill edging," which protected the bag from tearing or fraying.

More complex porcupine quill techniques are visible on the tail ornamentation of an early Fox *Midé Bag* (Pinjigosaun) in the museum's collection (see Harrison, "He Heard Something Laugh," pp.82–93, figs. 3 and 4). The designs on the hind paw panels were produced by wrapping porcupine quills around a network of deerskin thongs. "Netted quillwork" like this was often used to make garters, armbands, and sashes, or boldly patterned panels on bags and pouches. Zigzag bands and a "two-quill diamond" technique were used to create the intricately patterned design on the tail panel of the same *Midé Bag*. Porcupine quill embroidery on deerskin was one of the most ubiquitous art forms of the Great Lakes Indians as documented in early collections.[3]

Textile fabrics were produced only for the manufacture of sashes, garters, straps, bags, and mats, as documented among early collections. Vegetal fibers were used, occasionally supplemented with animal hair. Vegetal fiber burden straps, or "tump-lines," from several early collections are decorated with bold geometric patterns of dyed moosehair wrapped around the weft elements in a "false embroidery" technique.[4] Plaited mats made of reeds or cattails with designs in two-color tapestry technique were used as floor coverings and for seating.[5] Bags of vegetal fiber were made with a finger-weaving or twining tech-

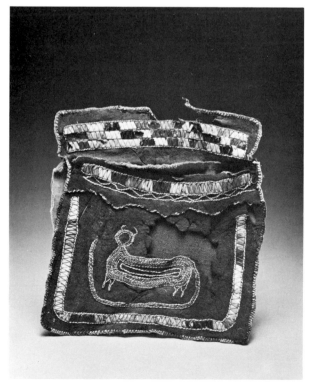

Figure 2.
Bag, Ottawa (Michigan), c. 1780; deerskin, porcupine quill, and pigment, 15.2 x 13.7 cm (6 x 5⅜ in.). Founders Society Purchase with funds from Flint Ink Corporation (81.487).

10

nique in which paired weft elements are twisted around warp elements. Storage bags utilized "simple-spaced twining" with alternately dyed warps that created striped patterns. The more complex "spaced alternate-pair twining," in which warps of contrasting colors of hemp and black animal hair were alternately twisted above or below each other in order to create elaborate designs, was employed to make bags for medicine bundles.[6] Many such bags were woven with representations of Underwater Panthers and Thunderbirds (see Phillips, "Dreams and Designs," pp. 52–69, figs. 1-14).

Traditionally, Native Americans looked to the world of nature for spiritual power. Animals were aligned with the spiritual realms above and below the world of man. Upperworld spirits were represented metaphorically by the Thunderbird, a giant celestial raptor, and Underworld spirits by the Underwater Panther, a giant horned snake or monster that lived beneath the waters of lakes and rivers. Shamans, humans empowered by spiritual gifts received from animal spirits (*manitos*, the Algonkian term for personal guardian spirits), interceded between the natural and supernatural worlds for the benefit of their tribe, curing the sick and strengthening hunters and warriors. Personal spirit power came from visionary experiences and dreams in which a manito revealed the supernatural powers of objects such as rocks, bones, plants, and other substances, which were then collected together in a bundle and kept as personal medicine for strength, healing, and protection.

Men's and women's art
The techniques reviewed thus far were all the province of women. Labor of all kinds, including the practice of various arts, was strictly divided among the sexes in Native American societies. While men hunted, women were responsible for preparing the meat, hides, and other useful products from game animals. Hence, the manufacture and decoration of clothing and other deerskin items fell to them. Women also collected wild plants for food so that the gathering of rushes, bast, and other materials for textiles logically came under their dominion as well.

Women's art, as seen on embroidered bags and clothing and in the textile arts, tended to be decorative and non-representational, consisting for the most part of repetitive geometric patterns with some interesting exceptions. Images of Underwater Panthers and Thunderbirds as design elements on deerskin and twined bags have already been mentioned. These mythic animals were regarded as extremely powerful sacred beings, and therefore their appearance on objects made by women is perplexing since religious matters were generally the concern of men. Women's images of sacred beings are confined to Thunderbirds and Underwater Panthers exclusively, however, or their analogs such as serpents, deer, and other varieties of birds. In the context of women's art, the images do not seem to represent specific religious powers, but rather personify concepts of the sky and underworld as more generalized sources of spiritual power. As such, they symbolize the idea of spiritual powers rather than specifying the powers themselves. Accordingly, such images are appropriate to the exterior decoration of pouches and sacred bundles since they do not reveal the specific nature of the religious objects inside, which tended to be personal and secret. Images of Thunderbirds and Underwater Panthers embroidered on deerhide pouches or represented in netted quillwork on bags, garters, and other elements of costume should be similarly understood as generalized power symbols testifying to the spiritual strength and social importance of the individual who wore them. In some cases, the images may serve as protective symbols, for example, when applied as the decorations of baby carriers.[7]

Men were responsible for carving and fabricating everything made of wood, antler, horn, and stone. While religious concepts in Native American art were often expressed in the veiled language of symbol and metaphor, certain categories of men's sculpture addressed religious themes in a more overt manner. Sets of bowls and spoons were made for personal and family use: every individual had their own utensils which they brought to meals and feasts. Wooden utensils were often carved with human and animal effigy appendages. These may represent manitos or refer to

folklore characters. For example, religious specialists sometimes cured an ill patient by providing him or her with a new set of wooden utensils carved with images of manitos. New initiates to the Midéwiwin society, a Great Lakes religious society (see Harrison, p. 85), were sometimes provided with new sets of utensils carved with sacred images for use during feasts held as part of the Midéwiwin rituals. Feast bowls of the Eastern and Yankton Sioux to the west are carved with images of "Eo," a spirit of gluttony, who was believed to live deep in the forest.[8]

Tobacco pipes were made from clay among the Iroquois to the east and sculpted of stone and wood to the north and west. Many of these pipes are modeled or carved with effigies of human-like heads or animals. These are often so personalized in execution that they defy any stylistic generalization. Among the Iroquois, effigies on pipes tend to represent beings acknowledged as having great spiritual power or *orenda* in Iroquois language.[9] Native statements confirm that effigies on many stone pipes portray the "animal soul" or spirit of the effigy subject.[10] Many early pipe effigies probably represent the personal *manito* of their owners.[11] Religious imagery on smoking pipes can be understood when the sacred character of tobacco and tobacco smoking rituals are considered. Tobacco origin myths of the Iroquoian and Algonkian speakers explain that the creator spirit made tobacco so that it could be smoked as offerings to spirits.[12]

Clubs with curved handles and spherical heads, often sculpted as an animal with a ball in its open jaws, are included among early collections (see Maurer, "Representational and Symbolic Forms in Great Lakes-Area Wooden Sculpture," pp. 22–39, figs. 3, 5-7). A relatively large number of angled "gunstock" clubs with incised pictographic designs that represent guardian spirits or coup marks (blows struck against an enemy) from the central and western Great Lakes region also can be dated as early as the mid-eighteenth century.[13]

Figural sculpture is rare among the arts of the Great Lakes Indians. Some small human figures carved of wood, often dressed in miniature clothes, were regarded as important sacred objects, such as the four small figures of the Man Clan sacred bundle from the Potawatomi of Mayetta, Kansas.[14] Other figures were employed for sorcery (magical affliction of harm against others), healing, or love magic.[15] The Chandler/Pohrt collection includes a large *Effigy Figure* collected from a Chippewa family at Cross Village, Michigan (fig. 3). Although it had lost any religious association for its owners at the time of its collection, it corresponds in style and scale to figures made by the northern Chippewa (also known as Ojibwa or Salteaux) called *manitoukanac*. These were erected outside the homes of their owners as protective spirits. The owners and visitors would frequently make offerings of tobacco, cloth, and other materials in thanks when they passed by, acknowledging their spiritual patronage.[16] The Chandler/Pohrt figure is painted a pale blue.[17] It has no arms, as is characteristic of *manitokanac* sculptures generally, and wears an hourglass-shaped frock coat. It is possible that the torso shape relates to the hourglass thunderbird configuration discussed by Phillips (p. 56).

Men were responsible for fabricating a great deal of equipment necessary to everyday life, and their artistic embellishments for the most part appear purposeful rather than decorative. The artwork was intended to add to the spiritual efficacy of the object just as good design contributed to utilitarian efficiency. When men created images they often corresponded to visionary experiences which were interpreted as gifts of power, so that the image can be understood as the representation or even manifestation of that power. The visionary sources of Great Lakes Indian sculpture contributed to a personal, individualized character that was a source of great inventive accomplishment.

The impact of European-American trade

From the earliest episode of Native American and European contact, the relations between these two cultures were conducted through the practice of trade. Europeans offered manufactured

products of the early industrial era—woolen and cotton fabrics, metal implements, and glass beads—for furs and hides of North American wildlife. The earliest collections of Native American art show evidence of this trade through the incorporation of manufactured materials in the construction of objects and through technical innovations made possible by new materials. Some of the earliest examples of European trade goods employed in the decoration of Indian costume include small cones made of coiled scrap tin that embellish early moccasins and deerskin bags as replacements for bell-shaped deer-hoof or dewclaw pendants. Rows of glass beads were occasionally used to decorate the edges of exceptionally early bags, moccasins, and garments. Garters and sashes made of netted quillwork or twined from vegetal fiber with moose-hair false embroidery were quickly replaced by counterparts made of wool ravelings of blankets, when available, incorporating patterns of interspersed white glass beads. A particularly fine example of this kind of textile is represented by a large *Sash* from the museum's collection, made by the Ottawa of Cross Village, Michigan (fig. 4). Red, yellow, and black wool yarns were woven together with a technique resembling braiding to produce a pattern of horizontal stripes. White glass beads were strung on the yarn at regular intervals to produce zigzag and chain-link patterns. This impressive sash illustrates how imported materials were adapted to meet indigenous ideological and esthetic requirements.[18]

The fabrication of clothing from trade materials and all manner of stitch-work remained the province of women. By 1800, many Great Lakes people wore garments fashioned from cotton and wool fabrics, although hides continued to be employed for moccasins and pouches.[19] The influx of European trade materials and the influence of European-American fashion resulted in a revolution in the area of women's arts. In addition, as tribal groups moved westward (initially as a consequence of conflict with the militaristic Iroquois and later as a result of forced removal under the jurisdiction of the United States government), diverse tribes came into closer and more sustained contact

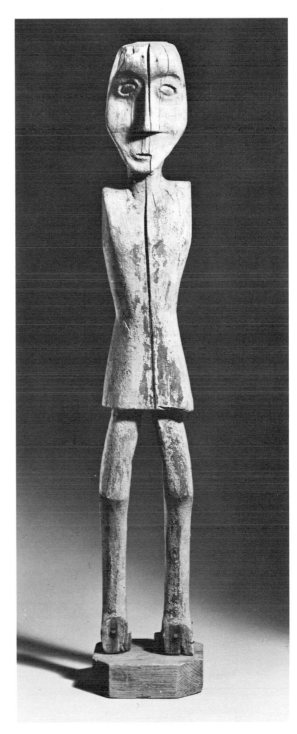

Figure 3.
Effigy Figure, Chippewa (Michigan), 19th century; wood and pigment, 89.5 x 14 cm (35¼ x 5½ in.). Founders Society Purchase with funds from Flint Ink Corporation (81.67).

13

with each other which offered many opportunities to exchange styles and techniques. The pace of artistic change increased rapidly as women responded to the esthetic and technical possibilities stemming from many changes in material culture and exposure to a much broader range of artistic influence.

Two innovative arts technologies had been developed and diffused throughout the northeast at some time just prior to the beginning of the nineteenth century. Ribbonwork, a means of decorating the hems and cuffs of garments and moccasins with rows of silk ribbon in contrasting colors which were cut, folded, and sewn into repetitive triangular and diamond patterns, appears on objects from early nineteenth-century collections.[20] Ribbonwork grew in popularity and complexity throughout the nineteenth century, having a profound impact on Native American arts across a large portion of the continent. The second technique, woven beadwork, was to have even greater impact. It was eventually employed to make objects in many textile categories such as garters, sashes, and bags (see Lurie, "Beaded Twined Bags of the Great Lakes Indians," pp. 70–81). Several different methods were used to create woven beadwork, including straight weave, twining, loom-woven, and heddle-woven variations.[21] The origins of these methods are uncertain although twined yarn textiles with

interwoven patterns of white beads certainly represent an ancestral technique. Early nineteenth-century twined garters with solid glass "pony-bead"[22] patterns are made with a loose warp probably developed out of techniques used to produce earlier netted quillwork and the shell bead wampum belts of the Iroquois and Ottawa.[23] The use of a loom to weave porcupine quills into decorative bands for clothing and bags apparently coincided with loom-woven beadwork. The earliest known loom-made pieces of either material were produced by the Canadian Cree north of the Great Lakes toward the end of the eighteenth century.[24] Both ribbonwork and loom-woven beadwork required adaptations of European American manufacturing technologies in addition to trade materials: the use of scissors for cutting silk ribbons and the construction of simple fixed-warp looms.[25]

An early *Shoulder Bag* (fig. 5) from the Chandler/Pohrt collection illustrates some of the profound changes in Great Lakes Indian art during the first half of the nineteenth century. It is a fairly large bag, made as an ornamental costume accessory rather than a container, and constructed of black wool with calico cotton lining and silk edging. It has a broad woven beadwork strap and two oblong panels of loom-woven beadwork on the front, one above the other, with beaded fringes and yarn

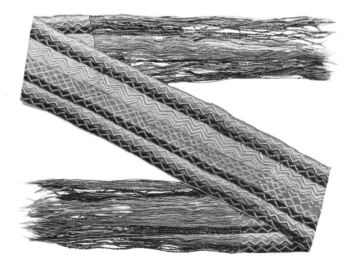

Figure 4.
Sash, Ottawa (Michigan), c. 1830; wool and glass beads, 141.6 x 24.5 cm (55¾ x 9⅝ in.). Founders Society Purchase (81.65).

14

tassels hanging in the space between. The floral motif in glass beads above the upper oblong panel is stitched in appliqué directly on the black wool fabric. The strap is made into two parts, each with a different design composed of two alternating geometric patterns on each side. Each motif is radially symmetrical and extremely complex, a characteristic of mid-century Chippewa woven beadwork design. The lower oblong panel on the face of the bag contains similar motifs, but the upper panel contains a written inscription, apparently a name, "BASIN DASIN." Andrew Whiteford has compared this bag with three other Chippewa bags also with written inscriptions on the panels, two of which include the dates "NOV 11 1850" and "mARs [sic] 21 1851". Details of construction, design, and decorative style clearly indicate that all were made by the same woman around 1850. Whiteford has also drawn a comparison between these Chippewa bags and Cree shoulder bags having pairs of loom-woven quill panels with fringes hanging from the lower edges, some of which date as early as 1800.[26] These four Chippewa bags with inscriptions are the earliest dated beaded shoulder bags of the Great Lakes type. Later bags dating between 1850 and 1880 or so were made entirely of loom-woven beadwork with larger, broader geometric designs.

While the geometric motifs represented on the loom-woven panels and strap harken back to Great Lakes quillwork designs and particularly to woven quillwork of the Chippewa and Cree after about 1800, the floral motifs executed in appliqué represent a new development in Great Lakes Native American art. The "floral style" of porcupine-quill and beadwork ornamentation on Great Lakes costume first appeared on objects collected around 1800 and grew in popularity so that by 1900, it was the dominant style of decorative arts among all the Great Lakes peoples. It has been proposed that the style was introduced to young female students at mission schools but exposure to popular European American "folk" styles of decorative arts certainly contributed to the diffusion of floral motifs across the Great Lakes region.[27] Some early nineteenth-century floral style objects, such as moccasins embroidered

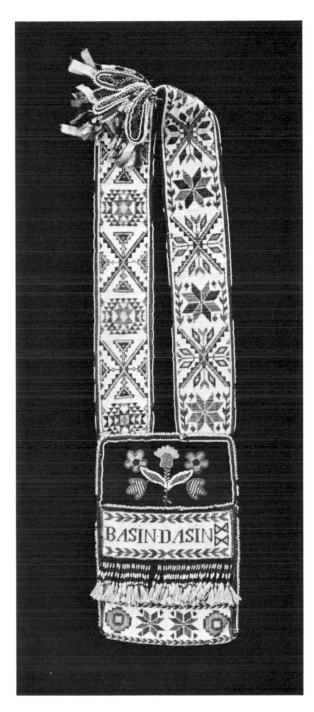

Figure 5.
Shoulder Bag, Chippewa (Michigan), c. 1850; wool, silk, and glass beads, 73.6 x 18 cm (29 x 7 in.). Founders Society Purchase (81.78).

the porcupine-quill embroidery technique except that glass beads were strung on cotton thread or sinew and tacked to a fabric backing at regular intervals, or "spots." The technique developed so that large solid areas could be filled with flat color, thus allowing greater compositional freedom than woven beadwork techniques. After 1875 or so, floral beadwork designs in spot stitch largely replaced woven beadwork on costume and shoulder bags, although woven beadwork ornament persisted in some contexts. Particularly among the Chippewa and their Cree neighbors to the north, floral designs became increasingly naturalistic and complex, often employing asymmetrical compositions, as Indian women became more familiar with the styles and compositional techniques of European American decorative arts. A pair of Chippewa *Man's Leggings* (fig. 6) dated about 1890 provides an excellent example of naturalistic floral style beadwork of the period executed in spot stitch. Details such as individual flower petals and the stems and veins of leaves are indicated by stitched rows of differently colored beads. The design meanders through the leg and cuff panels in a free-flowing arrangement, although symmetry is imposed when the designs of each legging are seen together. The design is contrasted against dark blue velvet fabric, which harkens back to the black and navy blue strouds (trade woolens) preferred earlier in the nineteenth century and, ultimately, to the blackened deerskin garments of the eighteenth century.

Figure 6.
Leggings, Chippewa (Minnesota); velvet, cotton braid, and glass beads, 74.3 x 20.3 cm (29½ x 8 in.). Founders Society Purchase (81.181.1).

A synthesis of style: abstract floral beadwork of the prairies

Additional historical factors contributed to an alternative development of the floral style. Land cessions, beginning with the Treaty of Greenville in 1795, pushed many members of Great Lakes tribes westward across the Mississippi. Early nineteenth-century reservations in the prairie and southern plains states of Iowa, Kansas, Nebraska, Arkansas, and Oklahoma placed bands of Great Lakes tribes in close proximity to southeastern groups such as the Cherokee, Creek, and Choctaw who had been similarly removed from their homelands, and the indigenous inhabitants of these territories, the Siouan speaking Oto, Osage, Ponca,

with elaborate assymetrical arrangements of naturalistically rendered flowers and foilage in moose hair, were made by the Huron and Iroquois of the Eastern Woodlands, most likely under direct European American tutelage and perhaps in response to requests for curios. Floral motifs spread to the west during the early nineteenth century and became increasingly stylized. This can be seen in the more static and symmetrical compositions made up of less naturalistic and simpler floral elements, as in the design on the BASIN DASIN shoulder bag. Early floral designs were often executed in porcupine-quill appliqué.[28] Spot-stitch beadwork is similar to

and Iowa, among others. The stylistic concepts drawn from all these diffuse peoples were synthesized into abstract floral beadwork decoration consisting of symmetrical arrangements of strange biomorphic forms with only the vaguest reference to flower representations. All were executed with broad areas of vibrant color (see Harrison, p. 82, fig.1). Abstract floral beadwork of the prairie region was one of the most original and inventive stylistic developments of nineteenth-century Native American art history.

The mid-nineteenth-century synthesis of Great Lakes and prairie Native American culture is particularly well illustrated by one of the best-known pieces in the Chandler/Pohrt collection, the Sauk and Fox *Bear Claw Necklace* collected by Milford G. Chandler on the Sauk and Fox reserve in Tama, Iowa (fig. 1). The necklace is composed of large grizzly bear claws strung in a radial formation with the foundation wrapped in otter fur. Large polychrome glass beads separate the claws, and circular rosettes of spot stitch beadwork ornament the collar. A long tail, or trailer, of otter fur decorated with rosettes of beadwork with silk ribbon pendants is attached to the rear of the collar by means of a rectangular panel of abstract floral beadwork executed in vibrant contrasting colors. The Fox, or Mesquakie, who had resided in Wisconsin during the seventeenth century, formed an alliance with the Sauk during the eighteenth century and were removed to reservations in Iowa and Kansas after the Black Hawk war of 1832. Bear claw necklaces are a man's ornament most characteristic of the prairie tribes whose territory corresponded to the range of the now-vanished prairie grizzly bear. During the nineteenth century, the Sauk and Fox were influenced by their prairie neighbors to develop a particular style of male formal costume which often combined fur turbans (another prairie costume element), bear claw necklaces, and clothing decorated with brilliant abstract floral beadwork decorations.[29]

This should not be considered simply one culture mimicking another but a response to a series of complex cultural and historical factors with innovative visual forms.

The visual arts of the period 1750 to just before 1900 underwent a great deal of technical and stylistic change. Rather than stemming from any single or unified arts tradition of an indefinite past, Great Lakes Native American art continually redefined tradition and made it relevant to a particular time and place. The process of reevaluating the past from the standpoint of the present is familiar to European Americans and yet it has been little recognized among Native American artists of the historic period. The concept of the artist engaged in defining culture amidst the complex mosaic of post-contact Native American history helps explain the artistic polarities, from careful historicizing to radical innovation, visible in Native American arts to the present day. With such an understanding in mind, and freed from the notion of a declining, conservative tradition, Native American art history can be accurately comprehended.

The Chandler/Pohrt collection

The collection now in the Detroit Institute of Arts began with Milford G. Chandler (1889–1981), an automotive engineer who was born in Walnut, Illinois, and spent a good portion of his early life in Chicago. He began to collect American Indian material at an early age, and eventually was sponsored by the Field Museum of Natural History to make collections for that institution. Chandler often traveled by train north to Wisconsin to collect among the Winnebago, Potawatomi, Menominee, and Chippewa who lived there. He also made extended trips to Mayetta, Kansas, to collect among the Potawatomi and to Tama, Iowa, where he developed long standing relationships with individuals on the Sauk and Fox reservation there. Chandler also gathered a large personal collection through these travels. He was a skilled craftsman and occasionally reproduced coveted objects he could not obtain. His interest in craftsmanship and technique, along with extensive first-hand study of many Indian art objects, infused his collecting with connoisseurship comparable to that of his more formally trained peers, such as George Dorsey of the Field Museum, Samuel Barrett of the Milwaukee Public Museum, and Frederic H. Douglas of

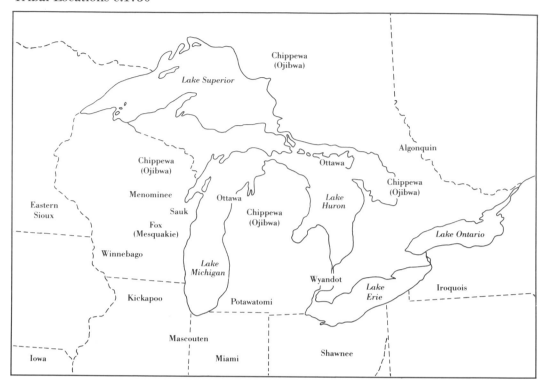

the Denver Art Museum. During his Chicago years, Chandler assembled a comprehensive collection of western Great Lakes works of art, numbering over a thousand individual items.

Chandler met the young Richard A. Pohrt (b. 1911) in Flint, Michigan, in 1926, when Chandler was hired by Marvel Carburetor Company to develop a fuel-injection system for military aircraft. These two men, a generation apart in age, then formed an association and friendship that lasted some fifty years until Chandler's death. Pohrt shared Chandler's enthusiasm for Native American life and culture. In 1933, Pohrt went to live on the Indian reservation at Fort Belknap, Montana, a location to which he has often returned. Pohrt managed to collect several important Gros Ventres objects and subsequently expanded his collecting activities, concentrating on the cultures of the Plains. Between the years 1935 and 1972, Pohrt worked for A.C. Spark Plug Company, a division of General Motors Corporation, in the personnel department. Although both Chandler and Pohrt assembled large and important collections of Native

American art, neither commanded resources of great wealth.

As Chandler grew older, Pohrt arranged to purchase his collection. Portions of the combined collections were featured at the Cross Village Indian Museum, run by Pohrt and his family at Cross Village, Michigan, until 1979. Many of the most important loan exhibitions of Native American art over the last few decades drew heavily from the combined collections. These included "Two Hundred Years of North American Indian Art" at the Whitney Museum of American Art in New York (1971), "Sacred Circles" organized by the Arts Council of Great Britain (1977), and "The Native Heritage" at the Art Institute of Chicago (1978). The most comprehensive public presentation took place in 1973 as part of the "Art of the Great Lakes Indian" exhibition organized by the Flint Institute of Arts.

The Pohrts closed their museum in 1979, and the Detroit Institute of Arts offered to purchase the entire Great Lakes assemblage as well as other Indian objects. Combining the collecting efforts of

both Chandler and Pohrt, the artifacts were accessioned as the Chandler/Pohrt collection of Native American art in 1981. In all, there are over 750 individual pieces. Comprehensive selections from the Chippewa, Ottawa, Potawatomi, Winnebago, and Sauk and Fox vividly portray nearly every aspect of costume, ornament, religious life, and fine arts. The collection also includes artistically rich selections of objects from the Plains tribes including the Sioux, Hidatsa, Crow, and Mandan. The Prairie tribes are represented by items from the Iowa, Omaha, Pawnee, Osage, Oto, and Kaw. Smaller groups of objects from the Micmac, Menominee, Wyandot, Miami, Montagnis, Delaware, Creek, Kickapoo, Arapaho, Ute, Shoshone, Blackfeet, and several other tribes are included as well.

Notes

1.
For a thorough discussion of the means and goals of Native American art history, see J. Vastokas, "Native Art as Art History: Meaning and Time from Unwritten Sources," *Journal of Canadian Studies*, 21, 4 (winter 1986/87): 7-36, particularly p. 13 and note 8, although in my opinion, art is a "cultural process" as much as the products that the process creates. While I agree that the object is the primary focus of art history, it is the art historian's task to reunite the object with the cultural processes and forces that shaped its creation, which from the creator's and consumer's point of view, are inseparable. In this sense, Native American art history joins the study of other cultural processes as represented by anthropology, archaeology, and ethnohistory.

2.
The Museé de l'Homme, Paris, possesses several small, exceptionally early collections of objects stemming from the voyages of Jacques Cartier (1534-1536, 1541-1542) and Samuel de Champlain (1604-1618) who came into initial contact with Iroquoian and Algonkian speakers of the Saint Lawrence region. Unfortunately, existing documentation does not allow isolation of the Cartier and Champlain material from collections drawn from other sources that date to the eighteenth century. (See A. Fardoulis-Vitart, "The King's Collection and the Ancient Collections of Curiosities in the Collections of the Museé de l'Homme," excerpts from the thesis diplome de l'E.H.E.S.S., Paris, 1979. I am indebted to John Painter of Cincinnati for lending me a copy of this manuscript.)

3.
See R. Odle, "Quill and Moosehair Work in the Great Lakes Region," in *The Art of the Great Lakes Indians*, Flint: Flint Institute of Arts, 1973, and J. Bebbington, *Quillwork of the Plains*, Calgary: The Glenbow Museum, 1982, for more detailed discussions of quillwork techniques.

4.
See, for example, R. Phillips, *Patterns of Power: The Jasper Grant Collection and Great Lakes Indian Art of the Nineteenth Century*, Kleinburg, Ontario: The McMichael Canadian Collection, 1984: nos. 23, 24. Two more burden straps of this type from the Messiter collection are illustrated in the Southwest Museum, Los Angeles, *Akicita: Early Plains and Woodlands Indian Art from the Collection of Alexander Acevedo*, 1983: nos. 65, 66.

5.
See C. Feest, *Beadwork and Textiles of the Ottawa*, Harbor Springs, Michigan: Harbor Springs Historical Commission, 1984: 15-16, nos. 14, 53, 54.

6.
See A. Whiteford, "Fiber Bags of the Great Lakes Indians," *American Indian Art Magazine*, 2, 3 (1977): 52-63; and Feest 1984 (note 5): 14-15 for more detail on twining techniques.

7.
For an examples of such baby carrier ornaments, see T. Brasser, *Bo'jou, Neejee: Profile of Canadian Indian Art*, Ottawa: National Museum of Man, 1976: no. 54; and J. C. H. King, *Thunderbird and Lightning: Indian Life in Northeastern North American 1600-1900*, London: The British Museum, 1982: no. 56. There is another illustrated in Phillips 1984 (note 4): no. 56, and two more in the Chandler/Pohrt collection at the Detroit Institute of Arts, 81.495.1 and 81.495.2, attributed to the Santee Sioux.

8.
For a discussion of effigy symbolism on Iroquois wooden bowls and ladles, see B. C. Prisch, *Aspects of Change in Seneca Iroquois Ladles A. D. 1600-1900*, Rochester, N.Y.: Rochester Museum and Science Center, Research Records No. 15, 1982: 51-60. For a discussion of Siouan bowls with Eo carvings, see J. C. Ewers, *Plains Indian Sculpture*, Washington, D.C., 1986: 171.

9.
See Z. Mathews, "Huron Pipes and Iroquoian Shamanism," *Man in the Northeast* 12 (1976): 15-31.

10.
See G. E. Laidlaw, "Ontario Effigy Pipes in Stone," *Annual Archaeological Report, Appendix to the Report of the Minister of Education, Ontario* (1914): 44-76, esp. p. 74.

11.
See Ewers 1986 (note 8): 52 for an account of how a Blackfeet warrior of the western Plains acquired "bear power," which resulted in his right to own a "blackstone pipe in the shape of a bear." The Blackfeet are Algonkian speakers related to the residents of the Great Lakes region. See Phillips 1984 (note 4) no. 45 for an excellent example of a carved wooden bear effigy pipe collected between 1800 and 1809.

12.

See T. Michaelson, "Notes of the Fox Wapanowiweni," *Bureau of American Ethnology Bulletin* 105 (1932): 127-32; and A. Skinner, "The Mascoutens or Prairie Potawatomi Indians: Mythology and Folklore," *Bulletin of the Milwaukee Public Museum* 6, 3 (1927): 368-71.

13.

For a discussion of imagery on Great Lakes war clubs, see T. Brasser, "Indian Art Around the Great Lakes" in *Pleasing the Spirits*, D. Ewing, 1982: 21. For a reference to images of guardian spirits on an early gunstock club, see J. B. Kohl, *Kichi-Gami: Wanderings Around Lake Superior*, London, 1860: 296-297.

14.

A. Skinner, "The Mascoutens or Prairie Potawatomi: Social life and Ceremonies," *Bulletin of the Milwaukee Public Museum*, 6, 1 (1924): 168.

15.

See R. E. Ritzenthaler and P. Ritzenthaler, *The Woodland Indians of the Western Great Lakes*, Milwaukee Public Museum, 1983: 96-97 (first ed. 1970, American Museum Science Books), and Skinner 1924 (note 14): 208.

16.

An important collection of this figure type can be found at the Glenbow Museum, Calgary. See N. Johnson, "Bits of Dough, Twigs of Fire," *Arts-canada* (Thirtieth Anniversary issue, *Stone, Bones, and Skin: Ritual and Shamanic Art*,) (Dec. 1973/Jan. 1974) pp. 61-69: nos. 184-187.

17.

According to G. Hamell ("Strawberries, Floating Islands, and Rabbit Captains: Mythical Realities and European Contact in the Northeast during the Sixteenth and Seventeenth Centuries," *Journal of Canadian Studies* [Winter, 1986-87] 21, 4: 72-94, p. 76) "sky blue," white, and transparency are sacred colors in Native American religious thought, connoting the social integrative aspects of "purposiveness of mind, knowledge, and greatest being."

18.

Hamell (1986 [note 17]: 72-94) writes about how thoroughly the cultural changes brought about by the life of fur-traders and the introduction of trade materials were incorporated into an ongoing traditional and mythic reality. See also Penney and Stouffer, "Horse Imagery in Native American Art," pp. 40–51, for a discussion of this theme with regard to the introduction of the horse.

19.

For descriptions of Great Lakes Indian clothing and dress around Amherstburg, Ontario, between 1806 and 1809, see the letter from British military officer Jasper Grant reproduced in Phillips 1984 (note 4): 32-34. Grant's papers also include a transcript of an address made by Tecumseh in 1807 in which the visionary Indian leader admonished his followers for adopting the dress of European Americans (R. Phillips, "Jasper Grant and Edward Walsh: The Gentleman-Soldier as Early Collector of Great Lakes Indian Art," *Journal of Canadian Studies* 21, 4 [Winter, 1986-87]: 56-71, p. 65).

20.

Phillips 1984 (note 4): nos. 9, 10, 31-34.

21.

See F. D. Lessard, "Great Lakes Indian 'Loom' Beadwork," *American Indian Art Magazine* 11, 3 (Summer, 1986): 54-61, 68-69.

22.

The term pony-bead refers to a type of glass trade bead typically used in early nineteenth-century objects. They are generally white, red, blue, or black and slightly larger than the seed-beads used in later beadwork.

23.

A fine single garter of this type and two sashes, attributed to the Ottawa and Potawatomi, made with red and green wraps and possessing a bold design in white and black pony beads are preserved in the Chandler/Pohrt collection (81.312, 81.198, 81.132). They compare closely with a pair of garters in the Museum für Völkerkunde, Berlin (see Feest 1984 [note 5]: nos. 30, 37).

24.

See B. L. Landford, "Great Lakes Woven Beadwork: An Introduction," *American Indian Art Magazine* 11, 3 (Summer, 1986): 62-67, 75; and Phillips 1984 (note 4): nos. 11, 14, for early examples.

25.

K. Abbass discusses the crucial role of scissors in ribbon-work technology in her study of Great Lakes ribbon-work soon to appear in the *Milwaukee Public Museum Bulletin* (in press). Fixed-warp looms for beadwork and quill work were simple frames or box-like affairs. Two typical examples are illustrated in Ritzenthaler and Ritzenthaler 1983 (note 15): 70. Wooden heddles are sometimes employed with looms, creating a slightly different weave called heddle-woven beadwork, see Lessard 1986 (note 21): 60-61.

26.

A. Whiteford, "The Origins of Great Lakes Beaded Bandolier Bags," *American Indian Art Magazine* 11, 3 (Summer, 1986): 32-43.

27.

See A. G. Bailey, *The Conflict of European and Eastern Algonkian Cultures 1504-1700*, Toronto, 1969: 148-151, for a discussion of this question. The mission schools cited by C. M. Barbeau, in his "Origin of Floral and Other Designs Among the Canadian and Neighboring Indians," *International Congress of Americanists, Proceedings* (1930), were active during the mid-seventeenth century, however, while the floral style does not appear among field-collected objects until nearly 1800.

28.

For an important early collection of floral designs executed in porcupine quill on birchbark, see Harbor Springs Historical Commission, *Ottawa Quillwork on Birchbark*, Harbor Springs, Michigan, 1983: nos. 1-19.

29.

This mid-century Sauk and Fox fashion is particularly well-illustrated in a complete costume belonging to Moses Keokuk, son of the famous Sauk Chief Keokuk, made in the 1850s and now in the collections of the National Museum of Denmark. See R. Gilberg, "A Sauk Chief's Gift: The Complete Costume of Moses Keokuk," *American Indian Art Magazine* 12, 1 (Winter, 1986): 54-63.

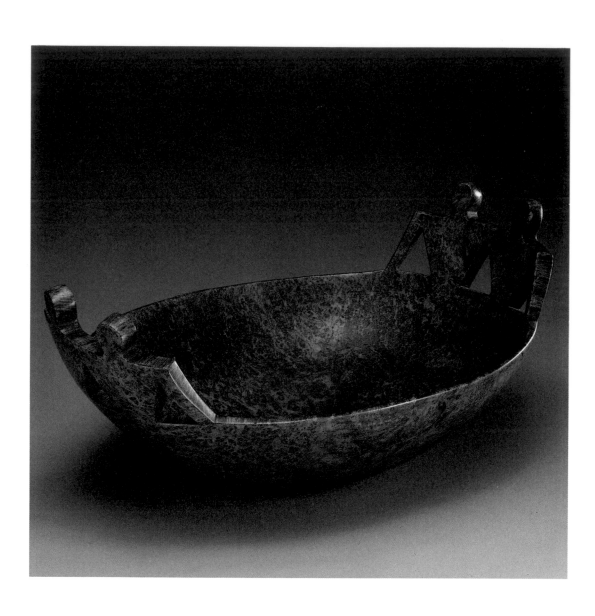

Representational and Symbolic Forms in Great Lakes-Area Wooden Sculpture

Evan M. Maurer

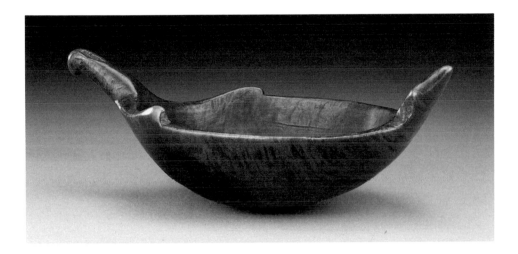

Figure 1 (opposite).
Bowl, Chippewa
(Michigan), c. 1850;
wood (ash), l. 48.3 x w.
33.3 x h. 21 cm (19 x
13⅛ x 8¼ in.). Founders
Society Purchase with
funds from Flint Ink
Corporation (81.748).

Figure 2.
Bowl, Winnebago
(Wisconsin), c. 1850;
wood (maple), l. 16.5 x
w. 9.2 x h. 5.2 cm (6½ x
3⅝ x 2¹⁄₁₆ in.). Founders
Society Purchase
(81.116).

The tribes of the Great Lakes and their neighbors in the Woodlands, Prairies, and eastern Plains have a rich cultural heritage whose visual arts utilize a variety of abstract, symbolic, and representational forms expressed in many techniques, materials, and styles. As was common in Native American cultures, most adult men and women of these tribes created various kinds of objects as an integral part of their daily existence. Because of the beauty of many of these objects, those who have studied them have isolated what we perceive to be the finest examples into a separate category considered "art." While Native American societies had a highly developed sense of aesthetics, neither their cultural practices nor their language separated the forms and functions of art from the basic patterns of their lives. For this reason the majority of objects that we categorize as Native American art have a utilitarian function or are based on utilitarian prototypes.

In Native American culture, social functions and the division of labor were determined by gender, with men and women being responsible for different aspects of daily life, from food production to the creation of clothing and household objects. In the Great Lakes and their contiguous areas, the technique of carving in stone or wood was exclusively practiced by men. Stone was primarily used in the ancient tradition of pipe carving that developed abstract shapes as well as an extraordinarily rich repertoire of animal and anthropomorphic forms. Wood, however, was utilized for the production of a great variety of objects.

23

In order to better understand the common characteristics of these wooden objects we can briefly describe them as being functional in purpose, minimal in their sculptural form, and very often associated with spiritual or religious uses. These categories of approach will be referred to in our discussion of individual objects.

The Detroit Institute of Arts is fortunate that the area of wooden sculpture is well represented in the Chandler/Pohrt collection. It features fine examples of most major categories of sculpture including crooked knives and mirror boards (see Penney and Stouffer, "Horse Imagery in Native American Art," pp. 40–51) as well as figures, spoons, quirts, sewing awls, bead loom heddles, feather box lids, flutes, prescription sticks, pipe stems, and maple sugar molds.[1] Some of these objects, such as the feather box lids or maple sugar molds, are carved in various depths of engraved line or bas-relief, but the majority are three-dimensional formal expressions—sculptures in the round created to be used, handled, and appreciated in a tactile as well as a visual manner. The basic characteristics of this type of Great Lakes sculpture are beautifully exemplified by three other kinds of objects in the collection: drumbeaters, clubs, and bowls. Through an examination of these wooden pieces we can come to a fuller appreciation of some aspects of the aesthetics and iconography of this important Native American artistic tradition.

Drumbeaters and clubs

A classic Chippewa wooden *Drumbeater* exemplifies the salient qualities of Great Lakes sculpture (fig. 4). It consists of a handle that gently narrows toward an angled head used to strike a skin-covered drum. The elegant proportions of the minimal form are heightened by the expertly carved and smoothly finished surface which shows no evidence of tool marks. The calculated visual harmonies are also expressed in the fine physical balance of the object when it is held in the hand. The man who carved this drumbeater was also able to integrate its functional purpose with a specific spiritual image, that of the loon, a bird which figures prominently in the mythical structure of the Midéwiwin society rituals in which this object was used. In many examples of this type, the characteristic features of the loon are expressed solely by the subtle carving of the form.[2]

In the Chandler/Pohrt example the head of the loon is emphasized by the addition of two brass tacks that represent eyes. By this simple and direct means the artist emphasized congruent parts of the drumbeater as the long neck and beak of the bird. That this minimally conceived form does indeed refer specifically to the loon as an important spiritual being can be seen in the Midé origin tale in which the loon "reached the entrance to the manito lodge, ran in as fast as possible, circling like a Midé . . . stretched his head over [the drum], and there appeared a drumstick."[3]

The sculptural and symbolic qualities of the drumbeater can also be seen in other types of utilitarian and ritual objects.

Figure 3.
Ball-Headed Club,
Chippewa (Walpole Island, Ontario), c. 1860; wood, l. 62.9 x h. 14.9 cm (24⅜ x 5⅞ in.). Founders Society Purchase (81.228).

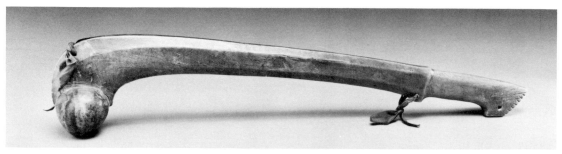

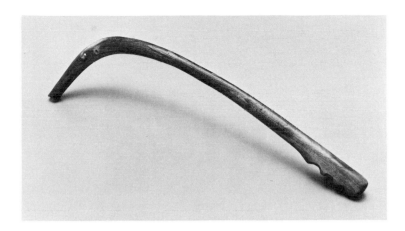

Figure 4.
Drumbeater, Chippewa
(Wisconsin/Minnesota),
c. 1880; wood (maple) and
brass tacks, l. 31.8 cm
(12½ in.). Founders
Society Purchase
(81.134).

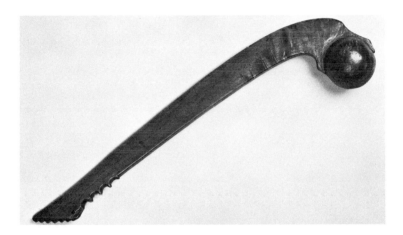

Figure 5.
Ball-Headed Club,
Ottawa (Emmet County,
Michigan), c. 1825; wood
(maple), l. 63.5 x h.
13.3 cm (25 x 5¼ in.).
Founders Society
Purchase (81.289).

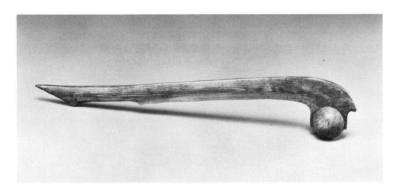

Figure 6.
*Miniature Ball-Headed
Club,* Potawatomi
(Wisconsin), c. 1850; wood
(maple?), l. 39.5 x h. 6.4
cm (15⅝₁₆ x 2½ in.).
Founders Society
Purchase (81.615).

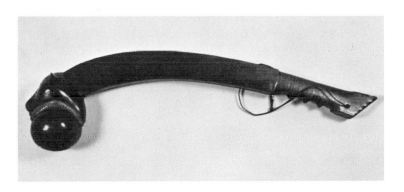

Figure 7.
Ball-Headed Club,
Iroquois, c. 1875; wood
and black, red, and
white paint, l. 50 x h. 7
cm (19¹¹⁄₁₆ x 2¾ in.).
Cranbrook Institute of
Science, Bloomfield
Hills, Michigan (3691).
Photo: Cranbrook
Institute of Science.

25

One of the most common weapons of the Great Lakes warrior was a ball-headed club carved from a single piece of wood. The fine Chippewa *Ball-Headed Club* (fig. 3) follows the typical form in which an articulated handle carved from a long, flat shaft curves into the rounded striking head. As these were functional weapons designed for hand-to-hand combat, the wood was carefully selected from that segment of a thick branch attached to the tree trunk, thus assuring that the curving form had structural strength based on the grain of the wood. Although the club was carved from a single piece of wood, the elements of handle, shaft, and head are clearly articulated and differentiate the individual character of each part.

As in the case of the drumbeater, carvers of ball-headed clubs often extended the functional form of the object to represent the head of an animal. In many examples, such as the Ottawa *Ball-Headed Club* (fig. 5), the formal difference is very subtle and involves the further articulation of the area where the ball joins the shaft of the club so that a generalized representation of an animal holding a ball in its open mouth is created. A *Miniature Ball-Headed Club* (fig. 6) from the Chandler/Pohrt collection made for use in a sacred war bundle shows another version of this motif. In this example the head of the animal also features a stylized ear whose curve reflects the shape and proportion of the open mouth.

That these minimal forms represent animals can be established by the many clubs in which the animal head is represented in a more realistic manner. An outstanding example of this clearly zoomorphic type is the Iroquois *Ball-Headed Club* (fig. 7) collected by Milford G. Chandler in 1919. Not only has the artist convincingly expressed the three-dimensional form of an animal's head, he has also given it an unusual amount of descriptive detail in the carved and painted ears, eyes, nose, and teeth.[4] While there is little documentary evidence concerning the meaning of these animal forms, it is generally assumed that they are metaphors that either express the physical strength and prowess of animals such as bears or felines or refer to the spiritual power

possessed by these animals in their important roles in the Native American mythological structure.

Carved bowls

The largest category of wooden sculpture from the Great Lakes and surrounding areas in the Detroit Institute of Arts' collection consists of a superb group of carved bowls. Bowls made from a variety of woods served as food containers for everyday use and for special feasts. Wooden bowls were also used in versions of a gambling game played with sets of dice-like objects.[5]

Until the late nineteenth century, the carved wooden food bowl was commonly found in every Native American household of the Great Lakes region. In about 1695, the French explorer Antoine de la Mothe Cadillac reported that at feasts among the Ottawa of Mackinac Island "the custom of the country is for each person to have his dish."[6] This custom was widespread and was also reported among the Huron and the Ojibwa (also known as the Chippewa);[7] in 1943 one observer commented that "at (Ojibwa) feasts every man carried his own wooden spoon and bowl to which the food was transferred with a large wooden ladle from the common cooking pot, a practice that continues to be followed on many of the reservations today with the tin pail and spoon."[8] References from the seventeenth through the nineteenth centuries describe the number and quality of "ye woden trayes & dishes they ate their meals in"[9] and report that the Iroquois and Delaware also manufactured wooden bowls for trade to other native groups or to the whites.[10] In the New England area it was noted that the Natives "have dainty wooden bowls amongst them; and these are disposed by bartering one with the other and are but in certain parts of the Country made, where the several trades are appropriated to the inhabitants of those parts only."[11]

While very little information exists on the methods used to make most categories of wooden sculpture, there are many references to the tools and techniques used in the creation of wooden bowls. Most Great Lakes-area bowls that have survived the vicissitudes of time were made from large burls or knots that

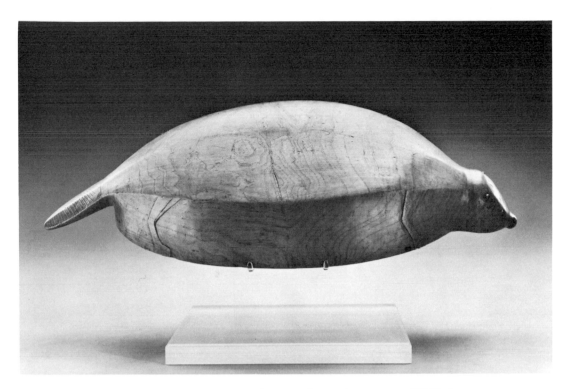

formed in the trunks of certain hard-
woods such as ash or maple. These
formations have an especially dense and
tight curving grain pattern which is
difficult to carve yet produces a very
durable object resistant to the cracking
and splitting that often occurs in pieces
made from straight-grained woods.

From the earliest times of European
contact, these wooden burls were used
for bowls. Gabriel Sagard Theodat, a
Frenchman who visited the Great Lakes
tribes in the years 1623-24, observed
that the men of the region made bowls
that they carved from knots of wood
using beaver incisors, a natural wood-
cutting tool also used by the carvers of
the Northwest Coast.[12]

Other native tools and techniques used
in bowl carving have also been
identified: "before the introduction of
steel knives, the wooden utensils were
made by charring and scraping with

bone and stone instruments."[13] Perhaps
the best description of this process was
written by Chandler:

> The old methods have served well
> enough but they were so time
> consuming and laborious. For making
> a wooden bowl, a burl had to be split
> off a tree with wedges of deer antler,
> roughly shaped by burning and
> scraping with spalls of flint until it
> was reduced to the approximate size
> desired. Then the inside had to be
> burned out with hot coals a little at a
> time, scraped with flint after each
> burning and wet clay applied at just
> the right time as the bowl thinned
> down. By grinding with coarse, then
> finer sandstone and polishing a
> smooth surface with deerskin and
> fine sand, the bowl was finally
> finished.[14]

This method persisted until the advent
of steel tools, the most efficient of which
was the curved-blade draw knife known
as a "crooked knife," which was used to
finish the carving and add sculptural
detail.[15]

While some of these wooden bowls were
made without any sculptural decoration,
a high proportion of the bowls that
survive in museum and private collec-

tions are embellished with carved rims using various representational and symbolic motifs. Bowls with these sculptural forms are generally assumed to be related to important social and religious functions, although there is a surprising lack of documentary evidence that one can cite to prove this supposition. The Bureau of American Ethnology's *Handbook of American Indians* notes that "wooden bowls used for religious purposes were often decorated (with) . . . figures of sacred animals, whose supposed spiritual power had relations to the uses of the vessel."[16] The *Handbook* also states that "the Micmac accorded supernatural powers to certain of their bowls, and thought that water standing over night in gaming bowls would reveal by its appearance past, present, and future events. Some bowls were supposed to have mysterious powers which would affect the person eating or drinking from them."[17] Other commentators concur that bowls "designed for the Grand Medicine Lodge ceremonies, the Dream Dance Religion, and other important religious functions were often made from hard tree burls and decorated with human or animal forms."[18] While it has been recognized that "the more elaborate animal forms may have been used for ceremonial purposes," it also has been noted that "we have no evidence that they were so employed."[19]

Given the numbers of decorated bowls that were reported to have been used in the Great Lakes region from the seventeenth through the twentieth centuries, it is all the more surprising and frustrating that so little is known about their actual use. This gap in our knowledge is evident when we review specific studies of such basic Great Lakes religious structures as the Midéwiwin. Although scholars have made frequent references to the many feasts that were an integral element of the Midé system, the bowls that were used are not described. In the earliest important study of the Midéwiwin Grand Medicine Society, frequent Midé feasts are discussed, but specific references to the types of bowls used are lacking.[20]

The Native American collections at the Detroit Institute of Arts contain five wooden bowls that incorporate animal images. The largest of these is a very unusual example: a *Bowl in the Form of a Beaver* (fig. 8). The oblong shape of the bowl corresponds to the general proportions of a young adult beaver lying on its back. Even the short, broad head is carved out and might have functioned as a pouring lip to serve individual guests when this large bowl was used at feasts. The end opposite the head is marked by a realistically carved beaver tail complete with engraved crosshatching that evokes the texture of this part of the animal's body. Signs of wear on the tail suggest that it was utilized as a handle to hold or carry the bowl. These anatomical references are completed by indications of the four legs carved in shallow relief on the exterior sides of the bowl.

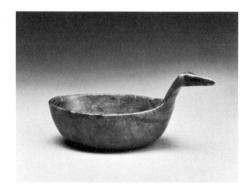

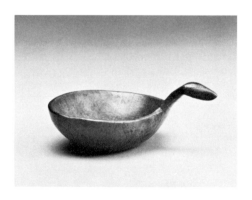

Figure 9.
Bowl, Winnebago (Wisconsin), c. 1860; wood (maple), l. 16.2 x w. 6.4 x h. 8.1 cm (6⅜ x 2½ x 3⅛ in.). Founders Society Purchase (81.409).

Figure 10.
Bowl, Winnebago (Nebraska), c. 1875; wood (ash), l. 9.5 x w. 8.6 cm (3¾ x 3⅜ in.). Founders Society Purchase (81.499).

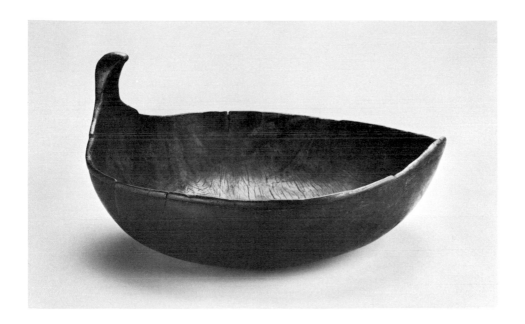

Figure 11.
Bowl, Sauk and Fox
(Tama, Iowa), 19th
century; wood, l. 42.6 x
w. 35.9 x h. 22.9 cm
(16¾ x 14⅛ x 9 in.).
Founders Society
Purchase (81.643).

This object is a prime example of the
sculptural conception of Great Lakes
animal effigy bowls in which the carved
elements that represent the animal are
not merely attached to the bowl as
additive decoration but are sculpturally
and conceptually integrated with the
form of the functional object. This
congruence of forms establishes the bowl
as the body of the animal and clarifies
our perception of the total object as a
sculptural metaphor.[21]

These animal effigy bowls were made in
a wide variety of styles, as can be seen
when we compare three Winnebago
bowls. The first example is a finely
carved *Bowl* (fig. 9) in which the long
neck and beak of a bird are joined to a
concave section of slightly oval shape.
The carved forms minimally indicate the
basic structure of the bird's neck and
head with the only detail being a slight
groove around the end of the beak to
articulate the mouth.

A very different style of effigy is
represented by a *Bowl* (fig. 2) in which
the carver has added forms to the rim
that symbolize the wings and tail of the
bird, thereby heightening the metaphor
of the bowl as the body of the animal.
The raised tail is balanced by the long
head and beak, whose tip ends in a
downward curve similar to that of the
loon.

Because of their small scale it is clear
that neither of these two bowls was used
to hold food. Traditionally called
medicine bowls, they are assumed to
have been used by Midé shamans to give
medicine to their patients in the curing
ceremonies that were a central feature
of Great Lakes culture. The bird, an
important Midé symbol associated with
the powers of the sky, appears on
engraved birch bark Midé scrolls, and
its form was used for the carved effigies
that surmounted the four poles of the
Midé lodge.[22] The long-beaked bird most
commonly mentioned in Midé myths is
the loon, so we might assume that, as in
the case of the *Drumbeater* (fig. 4), this
bird was the inspiration for those two
effigy bowls.

A third Winnebago effigy *Bowl* (fig. 10)
demonstrates an even more abstracted
sculptural vision. In this extremely
minimal example the animal forms have
been reduced to a short neck and a
triangular head with no indications of
anatomical detail. The form is so
generalized as to make it impossible to
identify it as a specific animal, yet its
shape is certainly zoomorphic.

29

A fine old Sauk and Fox effigy *Bowl* (fig. 11) in the Chandler/Pohrt collection exemplifies yet another formal conception of the bowl as a sculptural metaphor for an animal. In this type the effigy head faces the interior of the bowl. The smooth, generalized curves of the animal's head and neck are articulated into shoulders that join the rim. On the outer edge of the rim a carved band begins at the shoulder of the effigy and continues around the circumference to the opposite end of the oval, where it rises in a gentle curve to indicate the animal's tail. While the features of this effigy are minimal, the curve of the head and its pointed "mouth" are very similar to the graphic symbols of birds engraved on sacred Midé scrolls.[23] Visual evidence from these scrolls suggests that this avian figure may well represent the Thunderbird, an eagle-like bird of great spiritual power whose image was frequently found on Midé birch bark scrolls, woven into bag designs (see Phillips, "Dreams and Designs: Iconographic Problems in Great Lakes Twined Bags," pp. 52–69), or embroidered in porcupine quills on leather pouches.[24]

The orientation of the head toward the interior of the bowl (or the tail) establishes another perceptual metaphor in which the arms or wings of the animal can be conceived as extending from the shoulders to form the sides of the bowl. We can therefore perceive this type of effigy bowl as the sculptural representation of an animal on its back, its head erect and charged with the great potential energy associated with the ritual in which its body—the bowl itself—contains the offering of medicine or food.

Anthropomorphic bowls

Wooden feast bowls from the Great Lakes and surrounding areas were also carved in a variety of styles using anthropomorphic effigies in degrees of representation that range from examples with detailed physiognomy to ones that feature highly abstracted and conventionalized symbols. The Detroit Institute of Arts is fortunate that the Chandler/Pohrt collection contains a large number of extremely fine examples representing this sculptural tradition.

The origins of the anthropomorphic effigy bowls can be traced back to prototypes of the Mississippian period (about 700-1200). In a ceramic *Effigy Vessel* (fig. 13) found in Illinois, a short, thick neck supports a round anthropomorphic head with a flat face and three-dimensional renditions of eyes, nose, and mouth. The pair of large ears placed on the top of the head is similar to those appearing in depictions of bears, dogs, or other animals. This figure looks toward the interior of the vessel and is balanced by a curving projection that extends beyond the opposite rim, like the tail forms found on animal effigies. That this sculptural form was continued into historical Native American cultures is clearly seen when we compare the ceramic vessel to similar examples such as a Yankton or Eastern Sioux wooden effigy *Bowl* (fig. 12). The planes of the face in this example were subtly carved to achieve an expressive presence emphasized by the large staring brass tack eyes. As in the ceramic effigy vessel, the ears of the figure are placed in a vertical position where they look more like horns or animal ears than their human counterparts. The figure's neck flows in an even line to where it joins the rim of the bowl about ten centimeters (four inches) from the head; this raised portion of the rim is reflected on the other end by a similar form. The same concept of arms encircling the bowl, as evidenced in the Sauk and Fox animal effigy example (fig. 11), can be applied to these anthropomorphic bowls. The figure can be perceived as holding the bowl and its contents in a gesture that offers it to the user.

In comparison to the more disciplined precision of the Yankton or Eastern Sioux example, another Eastern Sioux effigy *Bowl* (fig. 14) was carved in a freer curvilinear style that softens the features of the face and the shape of the bowl. In this extraordinary piece of sculpture, the artist has reduced the anthropomorphic face to a broad oval dominated by deep hollow sockets that frame and accentuate the dull yellow gleam of the brass tack eyes. The image is one of arresting elemental power, despite the fundamental differences between the modern world and that of the traditional Native Americans who

30

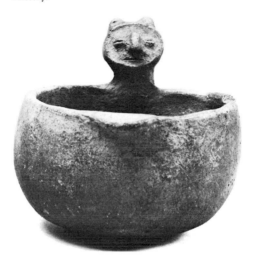

Figure 13.
Effigy Vessel, Early
Mississippian Period,
c. 700-1200; clay, h. 8 x
diam. 13 cm (3⅛ x 5⅛
in.). Field Museum of
Natural History, Chicago
(55566). Photo: Field
Museum of Natural
History.

Figure 12.
Bowl, Yankton or
Eastern Sioux, c. 1850;
wood with brass tacks, h.
13 x diam. 34 cm (5⅛ x
13⅜ in.). Collection of
Richard A. Pohrt.

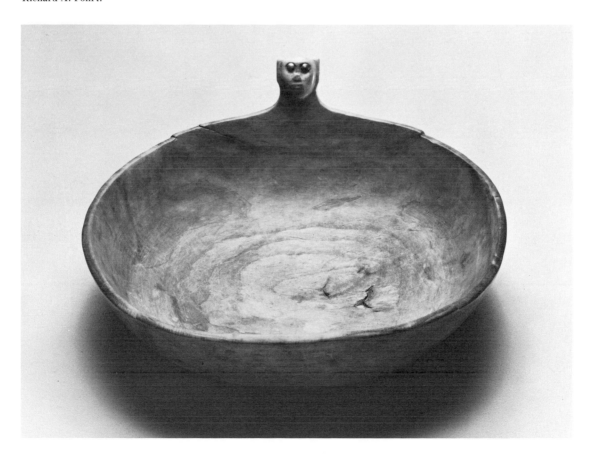

created and used this object in sacred ceremonies.[25] Anthropomorphic bowls were also produced with pairs of effigies facing each other as seen in a very fine *Bowl* (fig. 19) from the Sauk and Fox. The generalized curving forms of the two faces have the same intense stare that characterizes the two bowls just discussed. One of the most distinguishing elements of the Sauk and Fox piece is the manner in which the artist indicated the chests of the figures as they swell out into the interior. The effect is of the two figures growing out of the wall of the bowl, an extraordinary tour de force of artistic genius and technique.

An even more unusual display of anthropomorphic imagery can be seen in a unique Chippewa example that features pairs of figures at either end of an oval *Bowl* (fig. 1) carved from a beautifully grained maple burl. Here the figures are constructed of simple geometric shapes: circles for the heads, triangles for the bodies, and rectangles for the arms. Each pair of figures is joined at the shoulder, their bodies and arms formed by the negative spaces created by cutting three identical triangular shapes through the wall at the line of the rim. The figures arch backwards following the curve of the wall of the bowl. While the resulting angle integrates the figures with the larger form, it also adds a sense of movement and strain as we imagine the figures holding a large, heavy wooden feast bowl between them. As in all of these bowls, the minimal sculptural forms are reinforced by carefully controlled carving and finishing techniques which leave no evidence of tool marks.

Questions of use

While conclusive documentary evidence linking these effigy bowls to sacred rituals such as the Midéwiwin is lacking, the generally held theories as to their spiritual and religious functions quoted earlier can be supported by a compari-

Figure 14.
Bowl, Eastern Sioux (Minnesota), c. 1850; wood (maple), l. 43.8 x w. 39.8 x h. 18.4 cm (17¼ x 15½ x 7¼ in.). Founders Society Purchase with funds from Flint Ink Corporation (81.497).

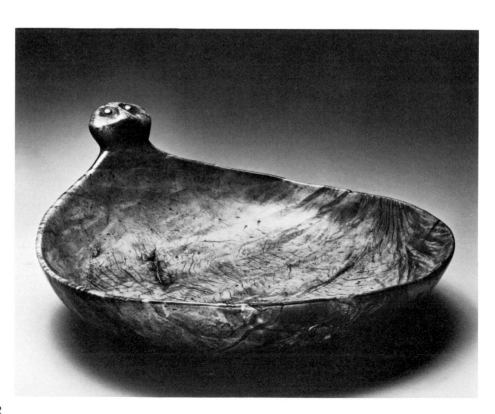

son of the images on the bowls with graphic and sculptural images that are securely related to the Midé rites.

Anthropomorphic figures of various types are frequently found on the sacred Midé scrolls, where they were part of the symbolic system of mnemonic aids that describe the mystic songs, rituals, and spiritual entities of the society.[26] In the majority of scroll examples, the figures do not represent human beings but powerful spirits, or manitos, which are personified by anthropomorphic forms. A circle is used to describe the head and curvilinear outlines or elongated triangles define the bodies of these highly stylized figures. In some cases these figures do represent human beings, specifically the various Midé officials or the patient/initiate for whom the ceremony is being performed.[27]

Anthropomorphic figures carved in wood were also used in Ojibwa Midé ceremonies.[28] Two distinct sculptural styles of these figures have been distinguished: the more naturalistic, featuring an oval face, large eyes, and long curving ears (see fig. 15), which created an image very similar to the Sauk and Fox effigy (fig. 19), and the more

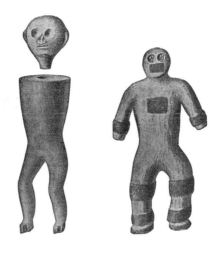

Figure 15.
Midé Effigy Figures. Photo: By permission of the Smithsonian Institution Press from *Seventh Annual Report of the Bureau of Ethnology to the Secretary of the Smithsonian Institution, 1885-86,* "The Midéwiwin of the 'Grand Medicine Society' of the Ojibway," Midé Effigy figures. Smithsonian Institution, Washington, D.C., 1891.

Figure 16.
Bowl, Chippewa (Michigan), c. 1860; wood (maple), l. 46.7 x w. 42.9 x h. 14.3 cm. (18⅜ x 16⅞ x 5⅝ in.). Founders Society Purchase (81.296).

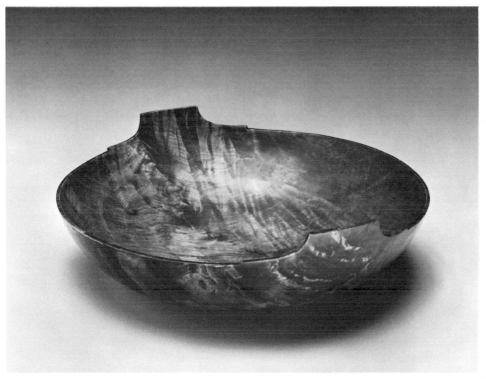

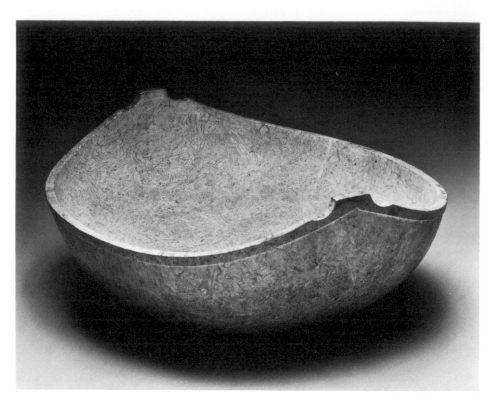

generalized, with forms dominated by a
large round head with big shell-button
eyes that produce a haunting stare
reminiscent of the face of the Eastern
Sioux effigy *Bowl* (fig. 14). Such
similarities in form and conception
demonstrate that the anthropomorphic
figures found on wooden bowls have
definite stylistic relationships to the
graphic and sculptural anthropomorphic
images associated with Midé ceremonies.
This evidence allows us to continue to
assume that the bowls have spiritual
associations related to the Midéwiwin
and its complex series of associated
ritual events.

Abstract Designs
The idea has been put forward that
certain abstract designs worked into the
rim of bowls were symbolic references to
animals; for example, a seventeenth-
century Wampanoag bowl whose
"handle, or projection rising from the

rim, seems to represent the convention-
alized head of an animal, the small
projections at either side indicating the
ears . . . the two perforations (eyes)
probably served for the passage of a
cord by which the vessel could be sus-
pended."[29] Our examination of the bowls
in the Chandler/Pohrt collection and
elsewhere supports such an iconographic
identification and, as we will observe in
the following examples, this identifica-
tion can shed new light on other wooden
objects.

The design described on the Wampanoag
bowl is a common motif found in
variations on many bowls. Two superbly
crafted examples of the type in the
Chandler/Pohrt collection are a low
round Chippewa *Bowl* (fig. 16) and an
Ottawa *Bowl* (fig. 17) with higher sides
and a more ovoid form. Both feature
opposing pairs of designs in which the
rim curves upward, then angles in to
form a horizontal shoulder. From this
point the form rises vertically and is then
truncated by another horizontal line.
When we compare this form to a repre-
sentational image of an effigy figure such
as that of the Yankton or Eastern Sioux
Bowl (fig. 12) or the Sauk and Fox
double effigy *Bowl* (fig. 19), the figural
qualities of the bowl become more

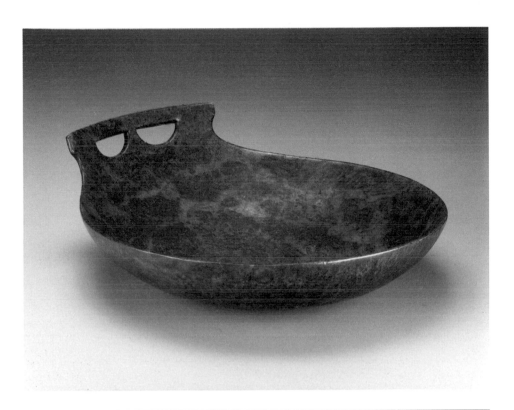

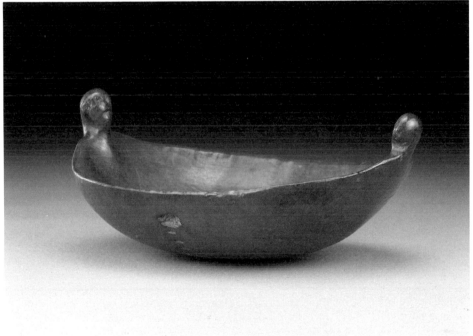

Figure 18.
Bowl, Eastern Sioux
(Minnesota), c. 1850;
wood (ash), l. 43.5 x w.
39.4 x h. 14 cm (17⅛ x
15½ x 5½ in.). Founders
Society Purchase
(81.625).

Figure 19.
Bowl, Sauk and Fox
(Tama, Iowa), c. 1860;
wood, l. 14.6 x w. 10.5 x
h. 5.7 cm (5¾ x 4⅛ x 2¼
in.). Founders Society
Purchase (81.411).

35

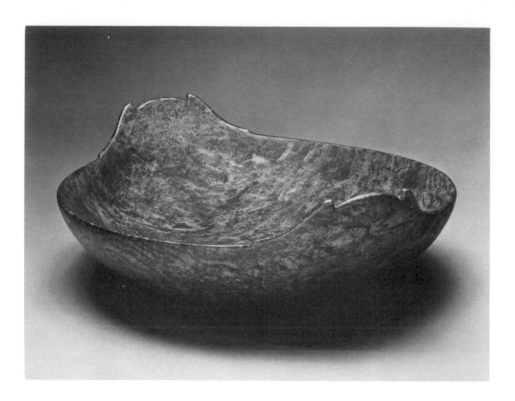

Figure 20.
Bowl, Eastern Sioux
(Minnesota), c. 1850;
wood (ash), l. 41.3 x w.
33 x h. 12.7 cm (16½ x
13 x 5 in.). Founders
Society Purchase
(81.624).

obvious, and, although the earlier sup-
position that this geometric design was
symbolic of a figure is confirmed, it
seems more likely that the designs are
symbols of anthropomorphic manito
spirits rather than animals.

The Chandler/Pohrt collection contains
another Eastern Sioux *Bowl* (fig. 20)
with a different variation of this theme.
This beautiful oval burl bowl also has a
matched pair of forms whose outline is
considerably less angular than those just
described. In this example the outline
curves directly upward from the rim to
indicate the top of an animal or anthro-
pomorphic manito head complete with
pointed ears.

Other variants of this general motif are
seen in bowls in the Chandler/Pohrt
collection from the Pawnee (figs. 21 and
22), and the Eastern Sioux (fig. 18).
Double-lobed types such as these Pawnee

examples are versions of the manito
image in which the ears have become the
sole distinguishing characteristic of the
head. This association can be supported
by comparing these forms to more fully
articulated examples such as a Sisseton
Sioux bowl in the Museum of the
American Indian, Heye Foundation, New
York, which has the same large curving
ear forms with the addition of a face
complete with nose, mouth, and brass
tack eyes.[30] If we accept that these
double-lobed designs are anthropomor-
phic, might the pairs of perforations in
the Pawnee and Eastern Sioux *Bowls*
(figs. 22 and 18) represent the eyes of an
abstracted face? In his study of wooden
bowls, Willoughby assumed that these
holes were used to hold cords by which
the bowl was suspended.[31] However, close
examination of the holes in these two
bowls shows none of the indications of
wear that would result from years of rub-
bing by a fiber or leather cord. This fact
would seem to corroborate the theory
that these designs are anthropomorphic.

The wooden bowls of the Chandler/Pohrt
collection constitute a major resource
for the study of Native American art
from the Great Lakes region.[32] It is
hoped that future investigations into the
ethnographic and historical record will

provide further evidence of their actual use in tribal culture and an understanding of the iconography of their forms. In terms of artistic excellence, these bowls represent a significant achievement within the history of Native American wooden sculpture.

Figure 21.
Bowl, Pawnee (Oklahoma), c. 1850; wood (ash), h. 14.3 x diam. 30.2 cm (5⅝ x 11⅞ in.). Founders Society Purchase (81.618).

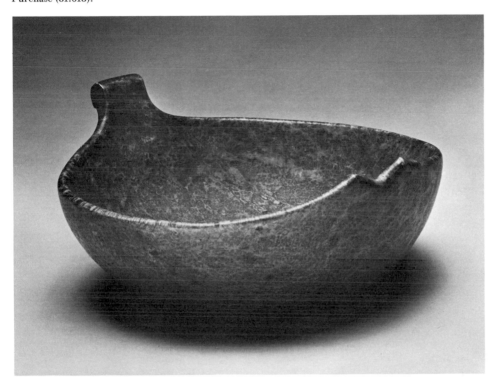

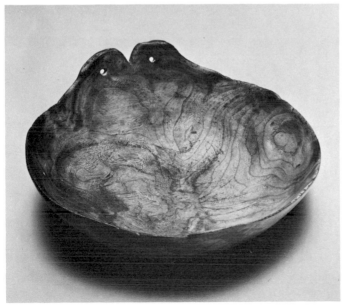

Figure 22.
Bowl, Pawnee (Oklahoma), c. 1850; wood, h. 12.1 x diam. 29.2 cm (4¾ x 11½ in.). Founders Society Purchase (81.820).

Notes

1.
For examples of Native American wooden sculpture, see Detroit Institute of Arts, *Forest, Prairie, and Plains: Native American Art from the Chandler/Pohrt Collection*, Detroit, 1983: figs. 1, 4, 11, and 12; Flint Institute of Arts, *Art of the Great Lakes Indians*, Flint, Michigan, 1973: nos. 64, 456, and 482; E. Maurer, *The Native American Heritage: A Survey of North American Indian Art*, Chicago: Art Institute of Chicago, 1977: no. 136; and N. Feder, *Two Hundred Years of North American Indian Art*, New York, 1971: nos. 139 and 140.

2.
See E. Maurer, *Native American Art: Selections from the Torrence Collection*, Des Moines: Des Moines Art Center, 1984: no. 80.

3.
R. Landes, *Ojibwa Religion and the Midéwiwin*, Milwaukee, 1968: 101-102.

4.
For comparative examples and further information, see Maurer 1977 (note 1): nos. 92 and 144; and D. Ewing, *Pleasing the Spirits*, New York, 1982: nos. 22, 107-110.

5.
F. W. Hodge, ed., *Handbook of American Indians North of Mexico, Bureau of American Ethnology Bulletin* 30 (1906): 164, reports that "bowls that had been long in use for these games acquired a polish and color unattainable by art and were prized as tribal possessions."

6.
Quoted in W. Vernon Kinietz, *The Indians of the Western Great Lakes 1615-1760*, Ann Arbor, Michigan, 1965: 240.

7.
B. Trigger, *The Huron Farmers of the North*, New York, 1969: 94.

8.
C. Lyford, "Ojibwa Crafts," *Indian Handicraft Series* 5 (1943): 31.

9.
Quoted in C. Willoughby, "Wooden Bowls of the Algonquian Indians," *The American Anthropologist* 10, 3 (1908): 423.

10.
Ibid.

11.
Ibid.

12.
Kinietz 1965 (note 6): 47, n. 121.

13.
These tools and techniques are mentioned in Lyford 1943 (note 8): 31.

14.
M. Chandler, "Art and Culture of the Great Lakes Indians," in Flint Institute of Arts 1973 (note 1): XXII.

15.
For a discussion of stone versus metal tools, see Willoughby 1908 (note 9): 433.

16.
Hodge 1906 (note 5): 164.

17.
Ibid.

18.
Feder 1971 (note 1): 10-11.

19.
Willoughby 1908 (note 9): 426.

20.
W. J. Hoffman, "The Mide'Wiwin of 'Grand Medicine Society' of the Ojibway," *Seventh Annual Report of the Bureau of American Ethnology 1885-86* (1891): pl. XVIII. The only visual evidence of the use of carved wooden bowls is found in a drawing of a Midé priest extracting sickness from a patient by sucking through a bone tube. The artist depicted a wooden bowl with rim decoration: the drawing is not sufficiently detailed to render the exact nature of the carving and we have little evidence of the reliability of the artist as an accurate observer.

21.
Two beaver effigy bowls of a different style were collected in about 1797 among the Kaskaskia of Illinois by a Judge Turner. Both show the animal standing on its four legs. One example is in the University Museum, Philadelphia (Feder 1971 [note 1]: no. 129); the other in the Peabody Museum, Cambridge, Massachusetts (Maurer 1977 [note 1]: no. 130).

22.
Landes 1968 (note 3): 31, 52, 169, 179, 184, and 235.

23.
S. Dewdney, *The Sacred Scrolls of the Southern Ojibway*, Toronto, 1975: figs. 34, 35, 37, 81, 118, 162, and 163.

24.
Hoffman 1891 (note 20): 196, 203, 209, 219, and 230; and Maurer 1977 (note 1): nos. 77 and 122.

25.
In his collection notes Richard A. Pohrt identifies this bowl with "Eo," a mythical character associated with gluttony.

26.
Dewdney 1975 (note 23): figs. 56, 58, 59, 62, 83-85, and 113.

27.
Ibid.: figs. 66, 87-90; and Hoffman 1891 (note 20): 169 and 170.

28.
Hoffman 1891 (note 20): 205. This was documented by Hoffman in 1885.

29.
Willoughby 1908 (note 9): 427.

30.
Feder 1971 (note 1): no. 77.

31.
Willoughby 1908 (note 9): 426.

32.
There are five other wooden bowls in the Chandler/Pohrt collection not illustrated here, all of which have variations of the rim designs discussed in the text.

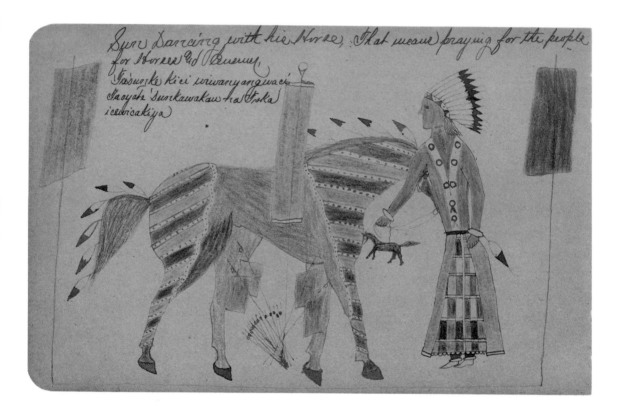

Figure 1.
"Sun Dancing with His
Horse, That means
Praying for the People
for Horses and Enemy,"
from an *Autograph
Book*, Sioux (South
Dakota), c. 1890; paper,
14.6 x 22.9 cm. (5¾ x 9
in.). Founders Society
Purchase (81.233.7).

Horse Imagery in Native American Art

David W. Penney and Janet Stouffer

The Plains Indian mounted on horseback has long personified the Native North American in popular culture. So closely are Indians and horses bound together in the public perception that it is surprising to learn that horses only became available to the Indians after the animals were imported to the Americas by Europeans during the sixteenth century. In fact, the thoroughness with which Indian people were able to adapt horses to their traditional life-styles characterizes the early Native American response to several European innovations such as metal tools and trade cloth. In each case a quick recognition of the new introduction's practical possibilities was followed by its swift synthesis with indigenous values and modes of thought. In the case of the horse, its thorough integration into the realms of material, social, and religious culture gave the animal a new and uniquely Native American character.

The frequency of equine images in Native American artwork testifies to the importance of horses, although the meaning of such imagery is not always clear. The integration of horses within Indian culture could only take place after the identity of the animal had been defined in terms of familiar categories. The creation of this new identity compelled Indian people to develop a series of associations and references linking horses to already existing cultural institutions. A horse image as a symbol on a specific kind of art object was intended to evoke these associations and references, to endow the object with meanings derived from the horse's acquired Native American identity. Horse imagery in Native American art concerns those larger cultural values that the animal came to represent and occurs in those specific artistic contexts in which those values were relevant. By examining the significance of the horse

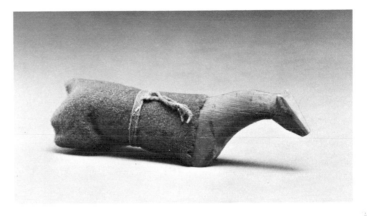

Figure 2.
Horse Effigy,
Potawatomi, c. 1870;
wood, fabric, and paint,
l. 13.7 cm (5⅜ in.).
Founders Society
Purchase (81.614).

in Indian culture and the kinds of artistic contexts in which equine images appear, the meaning of these images becomes clear. An important group of objects in the Chandler/Pohrt collection at the Detroit Institute of Arts provides an opportunity for such a study.

Horses and Indian Society
The earliest explorers of the North American interior, Hernando Desoto and Francisco Vasquez de Coronado, equipped their expeditions with horses in the 1540s. By 1600 the Spanish had established livestock ranches with large herds of horses in New Mexico. Trade with the colonized Rio Grande pueblos of that area and thefts by surrounding bands of Apache throughout the first half of the seventeenth century are the first documented instances of Indian ownership of horses.[1] By the beginning of the eighteenth century, such trade centers as the Taos pueblo, Sante Fe, and other New Mexico settlements, as well as raids by such southern Plains groups as the Commanche and Kiowa, had spread horses and horsemanship northward out

41

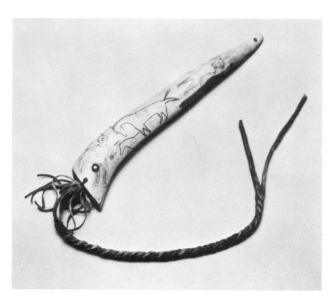

Figure 3.
Quirt, Osage, c.1850; elk antler, buffalo hide, and brass tack, l. including lash 85.8 cm (33¾ in.). Collection of Richard A. Pohrt.

of the Southwest. The Kiowa, Commanche, and other southern Plains tribes acted as middlemen for horse trade farther north. At the enormous trade fairs organized by the Hidatsa, Mandan, and Arikira villagers of the upper Missouri River, the Kiowa and Commanche exchanged horses, obtained directly from the Spanish in the Southwest, for corn. The Dakota Sioux, Plains Cree, Plains Ojibwa, and Assiniboine tribes of the northeast Plains acquired their horses from the Missouri River villagers. An alternate trade network covered the Indians of the eastern Rockies and plateau, such as the Shoshoni, Ute, Nez Percé, and Flathead, who then supplied the Blackfeet and Crow of the northwest Plains, feeding once again into the centrally located upper Missouri villages of the Hidatsa and Mandan. Early observations of these groups confirm that trade in horses on the high Plains was well established by 1750, and the genesis of Plains "horse culture" was well under way by the mid-eighteenth century.[2]

Historical reminiscences of Indians' initial encounters with horses describe the sighting of a new and unfamiliar animal in the possession of other peoples.[3] The Indians were surprised to find an animal that did not shy away from humans and allowed a person to ride upon its back. Fitting this novel species of animal into an Indian understanding of the world was achieved in various ways. A horse, first of all, was

a beast of burden capable of serving as a pack animal, pulling a travois (an A-shaped pole frame dragged behind the animal to transport a lodge skin and poles), or carrying a rider. The two functions of pack animal and travois-puller were previously fulfilled for the Indians by dogs, and the Sioux, for example, called their horses *sun'ka* ("dog"), or more explicitly, *sun'ka wa'kan* ("medicine dog" or "sacred dog").[4] The latter term reflects the wonderment with which the horse, an animal so closely allied with man, was regarded.

Many Plains tribes believed that horses possessed supernatural abilities, similar to those of other powerful animals such as the elk, bear, and buffalo. The Dakota Sioux, Blackfeet, and Assiniboine all had horse-medicine societies, in which guardian spirits conferred upon the members special powers for the care and healing of horses. All of these societies combined their secret rituals with public performances of what is known as the Horse Dance. Like many other Plains Indian medicine-society dances, the horse dance began with the construction of a dance lodge with an altar in the back. Part of the ritual included burning incense consisting of sweetgrass and juniper needles, smoking a sacred pipe as an offering to the sky and earth, and circle dancing to special songs, performed with the accompaniment of two drums and eagle bone whistles. The ceremony was followed by a public feast.[5] Horses sometimes joined the performers in the most sacred of Sioux religious ceremonies, the Dakota Sioux Sun Dance, a complex four-day ritual culminating in exhaustive dancing and sometimes self-imposed torture on the part of vision-seeking participants. Warriors often made vows to undergo a self-sacrifice ordeal in return for good fortune or special powers in combat. If enhanced speed, endurance, or performance was required of a horse, or if a larger herd of horses was desired,

the warrior might perform his ordeal with his mount.[6] A Dakota Sioux ledger book drawing (fig. 1) shows a warrior, accompanied by his horse, participating in such a ritual. The legend above the drawing indicates the Indian is "Sun Dancing with his Horse, That means praying for the People for Horses and Enemy." The warrior is dancing in order to benefit the community, increase his herd of horses, and insure successful combat over his enemies.

Some individuals were believed to have received shamanistic healing powers from horses. In one instance a horse was said to have assisted in a cure when an Assiniboine shaman led his horse to an ailing patient. After spewing blue, red, and black smoke from its nostrils, the horse placed its mouth over the sick man and drew out the disease-causing agents.[7] The Potawatomi of Mayetta, Kansas, possessed horse-medicine bundles that gave their owners strong healing powers.[8] Some of these bundles contained small horse effigies (see fig. 2), carved of wood, painted red, and

wrapped in red fabric, that functioned as medicinal objects.[9]

Theories concerning the genesis of the horse varied according to the tribe. The Dakota Sioux and the Potawatomi felt that horses derived their powers from their association with the Thunderbirds, and, like them, were spirits of the Upperworld.[10] According to Cheyenne thought, buffalo, corn, and horses all derived from a gift from an old woman in a cave.[11] The Menominee classified horses with other four-legged creatures of the earth, who all were thought to have originated in the Underworld.[12] Blackfeet myths have it both ways, describing an Upperworld genesis for horses in one version and an Underworld origin in another.[13] Horses did not easily fit into the categories of other wild animals because they were so closely linked with man and his lifestyle. The closeness of this relationship is made clear in an Assiniboine myth that describes how their culture hero, the Trickster, created both men and horses together from the dirt of the earth.[14]

Figure 4.
Pipe Bowl, Sioux (South Dakota), c. 1875; catlinite, 8.9 x 15.7 cm (3½ x 6 3/16 in.). Founders Society Purchase (81.671).

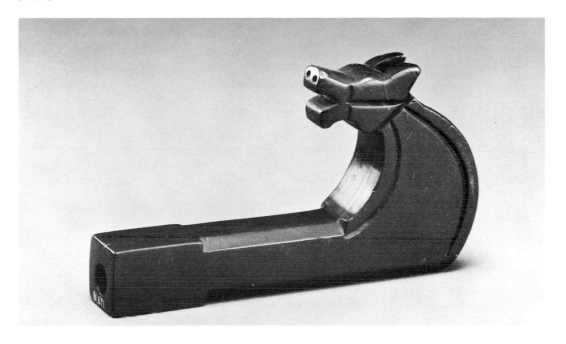

During the nineteenth century horses gradually became indispensable to Indian life on the Plains. The average Blackfeet household required ten to twenty horses simply to accomplish the day-to-day tasks of hunting and transportation.[15] An individual's status was reflected by the size of his herd, so that some outstanding leaders possessed more than one hundred animals.[16] Acquiring horses required either skill in trading or, more importantly, prowess in horse stealing. A successful raid against an enemy tribe's horses demonstrated courage and battle skills. Every Indian male of the Plains culture had to prove himself in forays into the territories of enemy tribes, where scalps, captured women, or, more often, horses were the rewards of success. A mature man with a large herd enjoyed prestige among his peers because his great wealth in horses reflected several daring campaigns of successful horse raiding. Such raids often became the subject of pictographic drawings in which the artist illustrated his own successes. A horse raid appears to be shown on an Osage *Quirt* (fig. 3), on which standing figures lead a small group of horses by their reins.

As a sign of wealth and prestige, the horse became the pre-eminent gift in nineteenth-century Plains Indian society. A proposal to a potential bride was accompanied by the gift of a horse to her family with many more horses presented at the time of the wedding.[17] Payment for memberships in dance societies or for services such as child naming, the cutting of the flesh during self-sacrifices by Sun Dancers, or to medicine men for curing ceremonies and sacred bundles were all made with horses.[18] In this regard, the horse ceased to be simply a unit of wealth, becoming instead a symbol for the creation of the new social possibilities that such gift-giving made possible. The presentation of a horse was a gesture of the highest regard, and an individual garnered status and social position through his distribution of horses.

For the Plains Indian, the primary cultural values associated with the horse were great spiritual potency, bravery, military prowess, wealth, largesse, and prestige. These same values were the measure of success among all aspiring Plains Indian men. As a symbol, therefore, the horse came to personify all of these male virtues and was used in various artistic contexts to evoke the positive qualities of the male role in Native American society.

Horse Sculptures

Throughout the Plains tribes, it was the men who carved all pipe bowls; some sculpted their own, while others specialized in pipe carving for payment.[19] The pipe bowl functioned as an important area for sculptural expression. Motifs occurring on pipe bowls include human figures, geometric designs, and, most frequently, animals such as buffalo, bears, and horses. Since these animals often represented potent spiritual powers, the carving of their forms on pipe bowls affirmed the pipe's role as an important ritual object. Many tribal groups distinguished between sacred pipes, those associated with medicine bundles and sacred rituals, and social pipes, those owned by an individual for his personal use. However, any pipe could be consecrated through a prescribed ritual, and individually owned pipes were always regarded with reverence.[20] For these reasons, it is not possible to distinguish between sacred and secular pipes by their appearance. The motifs on secular pipes often contained spiritual associations since smoking a pipe was considered the equivalent to speaking a prayer. It was an evocation addressed to the sacred powers to witness a particular event, from a simple greeting among strangers to the most holy episodes of the Sun Dance. Since the spiritual well-being of the tribe was largely the responsibility of men, the pipe itself thus became a vehicle for the expression of the solemn social and religious roles of men.

Some of the most striking Native American horse sculptures occur on catlinite (a red stone quarried in southern Minnesota) pipe bowls made by the Plains tribes. The basic forms of the pipes, whether the inverted T-shape with a base that extends beyond the vertical bowl or the common elbow pipe, derive from ancient prototypes dating as early as A.D. 200. In one striking Sioux example (fig. 6), the distal portion of the extended base, past the pipe bowl, is

carved as a horse's head. By aligning the head and neck with the horizontal axis of the base, the artist has implied the forward pitch of a horse in motion. The animal's wild gallop is emphasized by the flying mane carved in relief and the glittering inlaid glass beads used for the eyes. In contrast, the graceful arc of the animal's neck carved on a Cheyenne *Pipe Bowl* (fig. 7) stresses the quiet beauty of a horse at rest. The Cheyenne pipe has two bowls; one drilled through the top of the horse's head and a second cylindrical bowl located just behind it. Another Sioux *Pipe Bowl* (fig. 4) is carved in a simple elbow shape, with the horse head arching back to face the smoker. The graceful silhouette is emphasized by the reduction of the basic forms into four cubic planes.

A remarkable sculptural interpretation of a horse is found on a *Mirror Board* (fig. 5) from the prairies of the eastern Plains. A mirror board is a flat wooden box inset with a trade mirror, and often decorated with brass tacks, inlaid lead, and carvings at the top. The mirror board in the Chandler/Pohrt collection is composed of a shallow, rectangular frame inset with a mirror that is bordered by large brass tacks. A carved horse head rises from the upper edge. A carved heart motif, outlined with small brass pins, has been cut through the animal's massive neck. Since glass mirrors received in trade had to be protected against breakage, the wooden boxes provided a necessary and practical frame. The reflective qualities of mirrors were well appreciated. Mirrors were used for the application of cosmetics and perhaps for long-distance signaling. Indians also believed that mirrors had magical properties. A mirror board in an Arapaho medicine bundle gave its owner the same qualities in battle as light reflected by a moving mirror, that is, he would be impossible to catch and harm.[21] Shamans of different tribes occasionally used mirrors to deflect the malevolent spells of other shamans[22] or to inflict blindness and death.[23]

Horse-head mirror boards are not uncommon.[24] They are related to a variety of other mirror board types from the eastern Plains; these, in turn, are closely tied to the Grass Dance, or

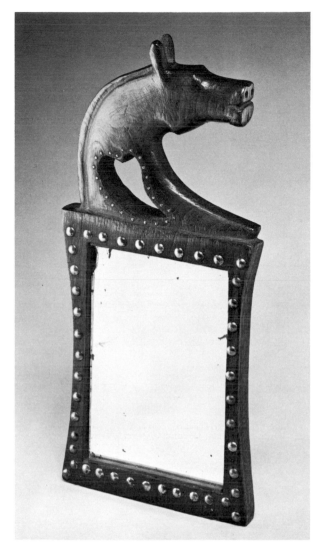

Figure 5.
Mirror Board, Omaha (Nebraska), c. 1885; glass, walnut, and brass nails, 5.9 x 16.2 cm (14⅛ x 6⅜ in.). Founders Society Purchase (81.427).

Omaha Dance. Mirror boards were used during the application of medicinal paints and cosmetics, and dancers carried them, either by the handle or by grasping the horse's head, while performing.[25] The practice of carrying a mirror board while dancing may have been related to the use of mirrors suspended in hoops by the Dakota Sioux Elk Dream Society dancers. Members of this group, a medicine society, derived

45

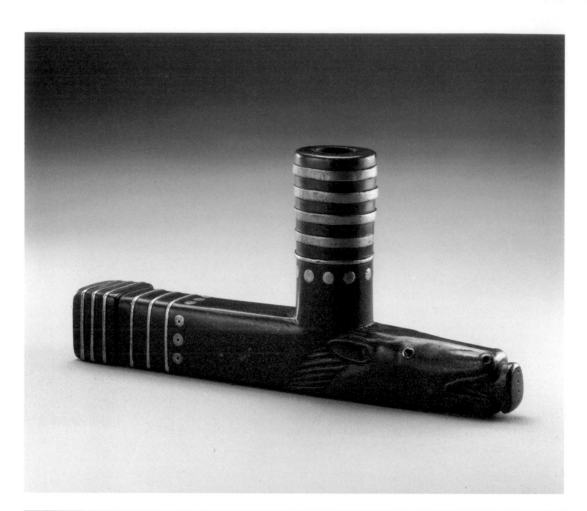

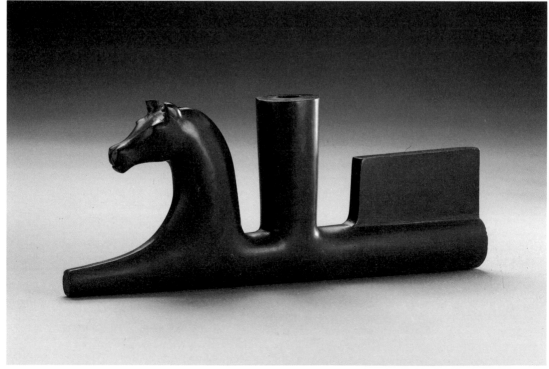

their healing and protective powers from dreams of the elk spirit. Their mirrors were believed to possess the power to detect ill-feeling and malevolent intentions directed toward the performers and therefore protect the dancers.[26] Mirror boards then may have had an apotropaic function: the ability to catch and turn back any evil that would interfere with a dancer's performance during the Grass Dance.

Horse imagery on mirror boards may stem from the character of the Grass Dance itself. The Grass Dance originated as a warrior society dance among the Omaha, Ponca, and Pawnee. The Dakota Sioux adopted the dance by 1860, and it spread to the Blackfeet, Assiniboine, Gros Ventres, and Arapaho, among others, during the latter part of the nineteenth century.[27] Many of the ceremonial aspects of the Grass Dance were lost in the course of its diffusion, with the result that the dance became essentially social. In its original form, however, it had celebrated the virtues of warriors and was intended to "stimulate an heroic spirit among the people and to keep alive the memory of historic and valorous acts."[28] These acts included many episodes of horse raiding. To symbolize horses taken in combat, the center of the Assiniboine Grass Dance drum was painted with horse tracks.[29] Blackfeet Grass Dancers carried a wooden staff carved as a horse to remind the people of their bravery and skill in raiding enemy horses.[30] During the period in which Indians lived on reservations, the Grass Dance gave men the opportunity to reaffirm their warrior roles of the past. Horse images on dance regalia such as the mirror board served as a reminder of the positive male values of courage and heroism.

The crooked knife, a unique Woodlands-area woodworking tool, provided another occasion for the use of horse imagery in decoration. A crooked knife is composed of a steel blade, often a reworked file, sharpened along one edge and curved to nearly ninety degrees at the tip. The blade is hafted to a wooden handle constructed with a leverage extension for the thumb. In this way the knife can be drawn toward the carver, with the palm up and the blade directed inward, using the full motion of the forearm as one would when using a drawknife or spokeshave. The curved tip could be used to hollow out wooden spoons and bowls.[31]

Most crooked-knife handles are undecorated, although all have the required thumb-lever extension, which sometimes is embellished with a spiral or other curvilinear form. Sculpted shapes, including carvings of human hands[32] and different kinds of animals, sometimes decorate handles. Horses are among the most popular sculpted handle designs. One of the earliest examples of a crooked knife with a horse-figure handle was collected in 1795 at Fort Michilimackinac, Mackinaw City, Michigan, and probably dates within a century or so of the first appearance of horses among those Indians who frequented the trading posts of the Chippewa, Ottawa, and Cree.[33] Other examples date from throughout the nineteenth century, demonstrating the link between symbol and object over several generations.

The Chandler/Pohrt collection includes two crooked knives with carved horse-head handles. As a pair, they restate the themes of motion and repose illustrated by the catlinite pipe bowls discussed earlier. One *Crooked Knife* (fig. 8) was collected among the Sauk and Fox of Tama, Iowa. The forceful arc of the elongated neck propels the head forward, a motion further emphasized by its converging planes, which meet at the rounded point of the muzzle. The other *Crooked Knife* (fig. 9) was collected from Beaver Island, just off

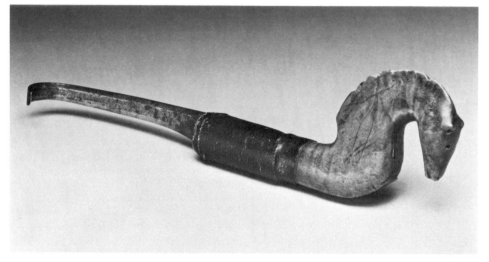

Figure 8.
Crooked Knife, Sauk and
Fox (Tama, Iowa),
c. 1840; steel, maple, and
rawhide, 27 x 4 cm (10⅝
x 1½ in.). Founders
Society Purchase
(81.498).

Figure 9.
Crooked Knife, Ottawa
(Michigan), c. 1860;
steel, maple, and
rawhide, 26.4 x 7.3 cm
(10⅜ x 2⅞ in.). Founders
Society Purchase
(81.293).

the west coast of Michigan opposite
Cross Village. The horizontal orientation
of the handle is interrupted by the
abrupt vertical created by the stately
arch of the horse's massive neck, which
directs the diminutive head downward.
In this case, the verticals emphasized in
the carving inhibit any feeling of
motion, creating instead a static
composition reflecting quiet repose.

The relationship between crooked
knives and horses derives from the use
of such implements for woodcarving,
canoe building, and general

construction. These were men's tasks
exclusively. This all-around
woodworking tool was essential to the
performance of the Native American
man's roles as constructor, builder, and
sculptor, in addition to those as
provider, hunter, and warrior. Thus, on
the crooked knife, the horse image once
again functioned as a sign of male roles
in Native American society, a symbol of
the tasks and roles that were considered
necessary to the success of the family
and band.

Horses transformed the whole of Native
North American society, but their

impact centered primarily on the traditional activities of men. Horses increased the mobility of the band and, concomitantly, the efficiency of the buffalo hunter. The horse expanded the geographic range of a raiding party, thereby extending the possibilities for military exploits by young men. Horses joined men in the sacred realms of medicine societies, shamanistic healing, and solemn religious ceremonies. The animals became a unit of wealth and large herds a measure of success, providing a means of upward social mobility for young aspirants and confirming the prestige of elders. Since hunting, warfare, religious life, and leadership traditionally were all areas of male endeavor among Native Americans, it is logical, therefore, that horse images proliferated on objects made and used by men. On these objects, equine imagery functioned to reinforce and recall male cultural values.

Notes

1.
The introduction of the horse to western North America is thoroughly discussed in D. Worcestor, "The Spread of Spanish Horses in the Southwest, 1700-1800," *The New Mexico Historical Review* 20 (1945): 1-13.

2.
For a discussion of the trade routes used to diffuse horses throughout the Plains region, see C. Wissler, "The Influence of the Horse in the Development of Plains Culture," *American Anthropologist* 16 (1914): 1-25; and J. Ewers, "The Horse in Blackfoot Culture," *Bureau of American Ethnology Bulletin* 159 (1955): 2-19.

3.
See, for example, H. Turney-High, "The Diffusion of Horses to the Flatheads," *Man* 35 (1935): 183-185.

4.
S. Riggs, "A Dakota-English Dictionary," in *U. S. Geological Survey of the Rocky Mountain Region*, vol. 7, ed. J. Dorsey, Washington, D.C., 1890: 450; and J. Dorsey, "A Study of Siouan Cults," *Eleventh Annual Report of the Bureau of American Ethnology* (1890): 479.

5.
Ewers 1955 (note 2): 95-98; C. Wissler, "Societies and Ceremonial Associations of the Oglala Division of the Teton Dakota," *Anthropological Papers of the American Museum of Natural History* 11 (1912): 95-98; and R. Lowie, "The Assiniboine," Ibid. 4 (1909): 57-58.

6.
F. Densmore, "Teton Sioux Music," *Bureau of American Ethnology Bulletin* 61 (1918): 131.

7.
Lowie 1909 (note 5): 44.

8.
A. Skinner, "Mascouten, or Prairie Potawatomi," *Milwaukee Public Museum Bulletin* 6 (1923-26): 189-193.

9.
A Potawatomi horse-medicine bundle with two horse carvings is illustrated in J. Clifton, "Potawatomi," in *Handbook of the North American Indian: Northeast*, vol. 15, ed. B. Trigger, Washington, D.C., 1978: 736, fig. 9. The bundle is in the collection of the Museum of the American Indian, Heye Foundation, New York (2/7810).

10.
R. Lowie, "Dance Associations of the Eastern Dakota," *Anthropological Papers of the American Museum of Natural History* 11, 2 (1913): 122; and Skinner 1923-26 (note 8): 366.

11.
G. Dorsey, "The Cheyenne: Ceremonial Organization," *Field Columbian Museum Publication 99*, Anthropological Series 9, 1 (1905): 40.

12.
A. Skinner, "Material Culture of the Menomini," *Indian Notes and Monographs* 20 (1921): 32.

13.
Ewers 1955 (note 2): 291-199.

14.
Lowie 1909 (note 5): 101.

15.
J. Ewers, "Were the Blackfeet Rich in Horses?" *American Anthropologist* 45 (1943): 609.

16.
Ewers 1955 (note 2): 29.

17.
A. L. Kroeber, "Ethnology of the Gros Ventres," *Anthropological Papers of the American Museum of Natural History* 1 (1907): 180; and Lowie 1909 (note 5): 40.

18.
C. Wissler, "Social Organization and Ritualistic Ceremonies of the Blackfoot Indians," *Anthropological Papers of the American Museum of Natural History* 7 (1911): 30; A. Bowers, "Hidatsa Social and Ceremonial Organization," *Bureau of American Ethnology Bulletin* 194 (1965): 289; and Lowie 1909 (note 5): 38.

19.
J. Ewers, "Blackfoot Indian Pipes and Pipe Making," *Bureau of American Ethnology Bulletin* 186 (1963): 34; and *Indian Art in Pipestone: George Catlin's Portfolio in the British Museum*, Washington, D.C., 1979: 21.

20.
J. Walker, *Lakota Belief and Ritual*, ed. R. J. De Maillie and E. A. Jahner, Lincoln, Nebraska, 1980: 87.

21.
W. Wildschut, "Arapaho Medicine Mirror," *Museum of the American Indian, Indian Notes* 4, 3 (1972): 253.

22.
R. Landes, *The Mystic Lake Sioux: Sociology of the Mdewakantonwan Santee*, Madison, Wisconsin, 1968: 47.

23.
C. Wissler, Notes on the Dakota Indians collected on the American Museum of Natural History expedition of 1902 at the Pine Ridge reservation, (unpublished manuscript, American Museum of Natural History, New York): 123. I am indebted to William Wierzbowski for providing me with this reference to the significance of mirrors in Dakota culture. According to a tale provided by the wife of Little Crow, a Dakota woman once dreamed of Double Woman, a Dakota culture hero. The next day blood ran from her nose, and she spit black dirt (earth-mud) from her mouth. She took a small mirror and flashed the sun in the faces of people and whenever she did this they fell down.

24.
A very similar mirror board from the Iowa is illustrated in N. Feder, *American Indian Art*, New York, 1969: fig. 50. It is in the collection of the Museum of the American Indian, Heye Foundation, New York (14/805). Another mirror board of the same type, also in the Museum of the American Indian, is attributed to the Mandan. In N. Feder, "Mirror Boards," *American Indian Hobbyist* (1959): 32, fig. 10, a drawing shows a horse mirror board held in the hand that is based on a photograph of a Pawnee dancer.

25.
See Feder 1959 (note 24): 32, fig. 10 and n. 23.

26.
H. Blish, *Pictographic History of the Oglala Sioux*, Lincoln, Nebraska, 1967: 201; and C. Wissler, "Some Protective Designs of the South Dakota," *Anthropological Papers of the American Museum of Natural History* 1 (1907): 42.

27.
J. Howard, "Notes on the Dakota Grass Dance," *Southwestern Journal of Anthropology* 7 (1951): 82-83.

28.
A. Fletcher and E. LaFlesche, "The Omaha Tribe," *Twenty-Seventh Annual Report of the Bureau of American Ethnology for the Years 1905-1906* (1911): 459.

29.
Lowie 1909 (note 5): 67.

30.
W. McClintock, "Dances of the Blackfoot Indians," *Masterkey* 11 (1937): 111-112.

31.
O. Mason, "The Man's Knife Among North American Indians: A Study of the Collections of the National Museum," *U. S. National Museum Annual Report for 1897* (1897): 730.

32.
The Detroit Institute of Arts recently acquired a superb example of a crooked knife with a handle carved in the form of a human hand (1986.20). It was published in P. Furst and J. Furst, *North American Indian Art*, New York, 1982: 225, pl. 227.

33.
The knife was included among the Foster collection at the Museum of the American Indian, Heye Foundation, New York (24/2017).

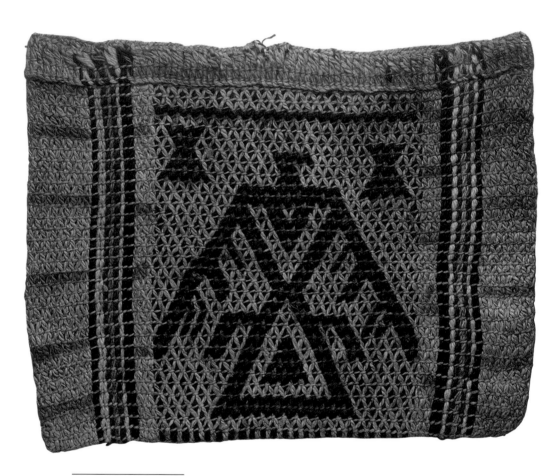

Figure 1.
Panel Bag, obverse,
Ottawa (Goodhart,
Michigan), c. 1860; wool
and nettle fiber cord,
42.6 x 21 cm (16¾ x 8¼
in.). Founders Society
Purchase (81.39).

Dreams and Designs: Iconographic Problems in Great Lakes Twined Bags

Ruth Bliss Phillips

The fifty-five bags in the Chandler/Pohrt collection of Great Lakes Indian art at the Detroit Institute of Arts are the products of one of the outstanding traditions of Native North American weaving. The technical sophistication of these bags has excited the interest of scholars for many years, while the rich variety of imagery they display continues to challenge our understanding. Twined (or finger-woven) bags were made by the Chippewa (also called the Ojibwa), Potawatomi, Winnebago, Menominee, and Sauk and Fox, as well as by a number of other Great Lakes and eastern Plains peoples. In the early decades of this century, sizeable collections of twined bags were acquired by major North American museums.[1] The Chandler/Pohrt bags are an important addition to this body of material not only because of the out- standing quality of many examples but also because a number of the bags were found in their original contexts as containers for medicine bundles. A striking example is a Chippewa *Panel Bag* (figs. 3 and 4) collected at Cross Village, Michigan, in the late nineteenth century. It displays on its two sides bold, beautifully drawn images of the major Great Lakes Indian supernatural beings, Thunderbirds and Underwater Panthers.

Although the making of twined bags seems to have died out among most Great Lakes peoples by the 1930s,[2] eth- nographers working at the beginning of this century were still able to collect extensive information about the prepa- ration of materials and weaving tech- niques. Twined bags were made for a wide variety of purposes, from the hulling of corn to the storage of food, clothing, and sacred medicines. Mate- rials and techniques of construction naturally varied according to the use for which the container was intended.[3]

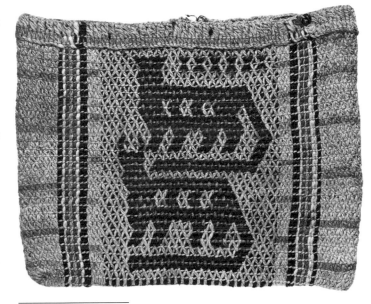

Figure 2.
Reverse of *Panel Bag*,
figure 1.

In comparison with our knowledge of technique, however, our ability to interpret the images woven into the bags is inadequate. This is surprising in that twined bags constitute one of the richest iconographic complexes in all of Great Lakes Indian art. Many early bags are adorned with beautifully rendered images of Thunderbirds and Under- water Panthers. Others bear depictions of deer, horses, dogs, turtles, and anthropomorphic figures, as well as a wide range of complex geometric pat- terns.[4] So far, however, the complete repertory of representational and abstract geometric imagery on twined bags from the Great Lakes region has not been systematically studied.

Several fundamental and fascinating iconographic problems arise when considering the Chandler/Pohrt collec- tion bags. Of central importance is the

relationship between representational and abstract imagery in the oldest type of bag. As we shall see, a radical change in technique and design occurred in twined bags during the nineteenth century when the clearly recognizable images of spirit-beings, called manitos, were gradually replaced by a type of bag whose ornamentation was geometric and non-representational. In order to understand the significance of this stylistic and iconographic development, a rigorous visual analysis of the overall range of motifs on woven bags is needed.

Fiber panel and banded woolen bags

Before turning to an examination of these issues, it will be useful to establish a technical classification of twined bags, for iconographic problems are closely associated with overall developments in technique and form (see also Lurie, "Beaded Twined Bags of the Great Lakes Indians," pp. 70–80). Two types of twined bags, both of which were used to store personal belongings or individual sacred medicines and medicine bundles, will be the focus of this paper. The older type of bag is generally regarded as an aboriginal form of container.[5] It is made of vegetable fibers (usually nettle stalk), which were used for both warp and weft. The warps were hung over a rod and paired wefts were woven spirally around them, working from the top (the bottom of the finished bag) down. Wool made from moose or buffalo hair was added to the weft to form the motifs; later, raveled and re-dyed blanket wool was used. The result was a seamless container which could range in length from approximately ten to fifty centimeters (four to twenty inches). The two faces of the bag were divided vertically into three compartments by striped vertical bands in colored wool. The large central rectangular panel contained single or multiple images which were nearly always different on the two sides. Representational and geometric designs occur on both early and later examples of this bag type, known as the fiber panel bag.

A dramatic change in the style and technique of twined bags may have begun as early as the mid-eighteenth century and seems to have been stimulated by the increasing supply of colored trade yarns.[6] Although the weaving of fiber panel bags has continued into the twentieth century, the new type of banded woolen bag had become much more common by the late nineteenth century and was used for the same purposes as the earlier type. Not only were new trade materials adopted, but major changes in twining techniques, construction, and designs occurred.[7] Banded woolen bags made after this time no longer display a large central rectangular panel, but are divided into three and sometimes four horizontal zones which are filled with repeated geometric motifs. A new technique, termed compact weft-twining, is employed that permits more frequent changes of motif and hue and results in a more richly colored and densely patterned surface. In compact weft-twining, paired weft elements twine around and hide the warps, making it possible for the weaver to vary color and motif by introducing new wefts where she chooses.

This later type of bag no longer exhibits the bold, clear images of mythological beings that are to be found on many of the fiber panel bags. The geometric designs that replace these representational images have not been closely analyzed, and they are usually alluded to as ornamental, decorative, and—by implication—devoid of symbolic meaning. Echoes of nineteenth-century cultural evolutionist theories can be heard in remarks which imply that representational imagery in the earlier bags later dissolved into fragmented, unreadable designs. Winnebago banded woolen bags, for example, are described as displaying "such degenerate geometric forms as to be unrecognizable." Similar Menominee geometric motifs have, on the other hand, been referred to as

Figure 3.
Panel Bag, obverse, Chippewa (Emmet County, Michigan), c. 1870; cotton fiber, 34.6 x 55.9 cm (13⅝ x 22 in.). Founders Society Purchase (81.37).

Figure 4.
Reverse of *Panel Bag*, figure 3.

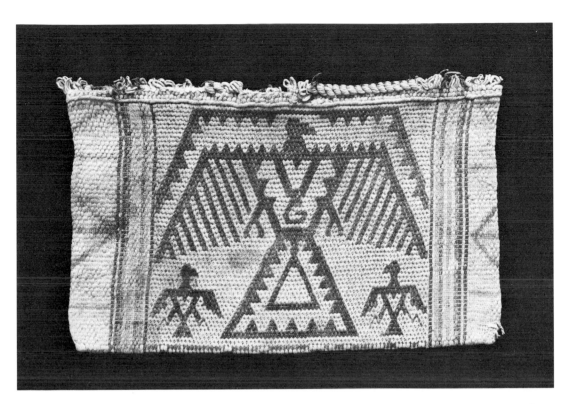

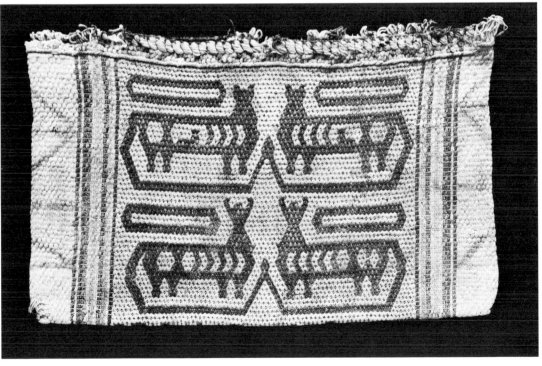

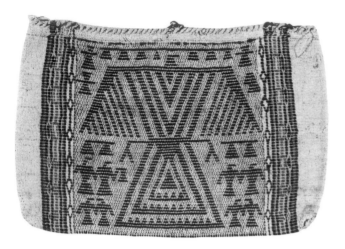

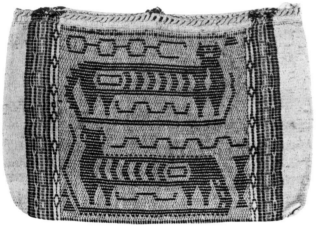

Figure 5.
Panel Bag, obverse,
Potawatomi (Wisconsin),
c. 1890; wool, 43.2 x 64.8
cm (17 x 25½ in.).
Founders Society
Purchase (81.372).

Figure 6.
Reverse of *Panel Bag*,
figure 5.

The Thunderbirds were a class of spirits that resembled powerful predatory birds. The Ojibwa related them to hawks, while the Winnebago conceived of them as eagles.[10] They were among the most popular and frequently represented guardian spirits, in control "of almost all the power that men can imagine."[11] Those who received visions of Thunderbirds were blessed with success in war and many other good things. The Thunderbirds were also associated with the rainfall necessary for successful cultivation. Lightning was said to be produced by the flashing of their eyes and thunder by the flapping of their wings. Many myths recount transformations of men into Thunderbirds and describe the manitos as organized into families analogous to the families of mankind.

Images of Thunderbirds on twined bags depict many of these attributes and powers. Three fine bags in the Chandler/Pohrt collection (figs. 3, 5, and 7) display the manitos adjacent to zigzag or jagged lines that represent lightning or thunderbolts. On each bag a large, fully described image is flanked by two or more smaller birds, a grouping that has been explained by some informants as representing "Thunderbirds and flocks of their young."[12] Another interpretation states that grouped Thunderbird images may symbolize a group of people bound together by ties of friendship[13] or, presumably, kinship. These depictions of Thunderbirds also display a series of conventional stylizations. The body is shown as two triangles joined together to form a stylized hourglass shape. Indeed on two of the Chandler/Pohrt bags (figs. 1 and 5) the hourglass stylizations representing smaller Thunderbirds are reduced to minimal geometric forms whose meaning must be deduced from their context. Another common stylization in images of Upperworld manitos is

"purely aesthetic."[8] In order to test these statements regarding the iconography of banded woolen bags, it is necessary to examine the relationship of abstract to representational design in the fiber panel bags that preceeded them.

Upperworld images

On a number of fiber panel bags one side bears a depiction of one or more Thunderbirds and the other side depicts single or grouped Underwater Panthers. According to traditional Great Lakes Indian cosmology, these two categories of manitos were the dominant spirits of the realms above and beneath the earth's surface into which the universe was divided. In the many accounts concerning the nature of these beings presented in the ethnographic literature, we find local beliefs and myths specific to particular clans or tribes, as well as a number of constant features attributed to the manitos by all peoples native to the Great Lakes region.[9]

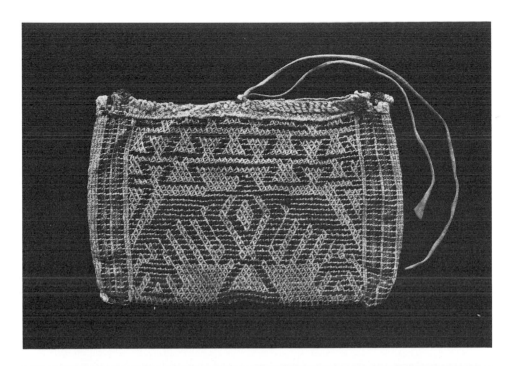

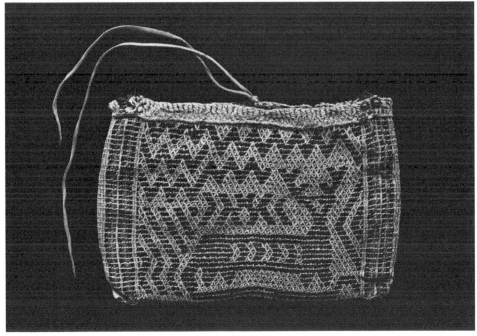

Figure 7.
Panel Bag, obverse, Sauk
and Fox (Tama, Iowa),
c. 1860; wool and nettle
fiber cord, suede end tie,
17.8 x 26.7 cm (7 x 10½
in.). Founders Society
Purchase (81.390).

Figure 8.
Reverse of *Panel Bag*,
figure 7.

the internal elaboration of the triangular- and hourglass-shaped forms of the torso, which are filled in with concentric triangles, chevrons, or diamonds. The central diamond or chevron in the upper torso depicts the heart in the "X-ray" manner common to images of spirits and power animals throughout the Great Lakes. The wings are normally shown as diagonal lines extending down from the torso and fringed with parallel lines representing feathers.

Underworld images

If we turn to Underworld imagery, the dominant mythological being is known by a variety of names that are usually translated as Underwater Panther. This manito was represented as a powerful cat-like creature with horns, which may have been based on the lynx's projecting tufted ears. A long, dragon-like tail that frequently displays triangular "scales" is shown coiled around the image (see figs. 2, 4, 6, and 8). Just as the Thunderbird was associated with storms in the skies, the Underwater Panther was associated with disturbances on water. Whirlpools and rough waters resulted from the swirling of its long tail, manifestations of cosmic forces that constituted serious dangers for people who traveled a great deal on lakes and rivers. Ethnographers have recorded many associations of danger with the Underwater Panther as well as the more generalized identification of the manito as an evil spirit. Despite these malevolent connections, there is good reason for caution in attributing such a moral dichotomy to the Upper/Underworld division of traditional Great Lakes cosmology. The interpretations recorded during the past hundred years undoubtedly incorporate elements of Christian cosmology in which the Underworld is a realm of evil and darkness. For the Great Lakes peoples, however, there is ample evidence that the underworld was also a source of constructive, creative powers in the form of medicines that could heal and prolong life. Various observers have noted that among the Chippewa "those who dreamed of water were usually the most successful in treating the sick."[14] The attitude of Winnebago informants toward the water spirit was ambivalent: "he is evil, yet his 'bones' are the most prized possessions of man on account of

the remarkable power with which they are endowed." The Winnebago regarded the water deity as partly good and partly evil, "always to be feared and capable of bestowing great blessings on man."[15] Myths also record successful encounters with the Underwater Panthers in which great wealth in the form of pieces of copper from the animal's long tail came to those humans involved.[16]

Representations of Underwater Panthers are also highly stylized though perhaps to a slightly lesser degree than those of the Thunderbirds. The Chandler/Pohrt bags display the catlike bodies, horns, and long tails associated with this manito. The ribs or "bones," mentioned as highly valuable medicine, are clearly shown in all the examples (see figs. 2, 4, 6, and 8). One of the depictions also includes elongated hexagonal forms, identified as representing sacrifices of food in bark dishes, which were intended to "keep them (the manitos) contented."[17] The long tail curving around the manito was termed by the Menominee "the Panther's road"[18] and its coiled arrangement is probably related to the peculiar water phenomena associated with it. In the myth referred to above, in which two girls gain wealth by acquiring a piece of copper from the Panther's tail, whirlpool is the channel or path to the panther's presence: "in the center of the mud was a hole of clear water . . . the water was swirling around the hole, and as they started to cross it, a lion came out of the middle and switched his tail across the boat."[19] Just as concentric chevrons or diamonds appear to be associated with depictions of the Thunderbird's torso and heart, concentric circles and concentric polygonal shapes appear to be associated with the Underwater Panthers. This motif is prominent in a Potawatomi fiber *Panel Bag* (fig. 6).

Two of the Chandler/Pohrt bags also display unusual iconographic features. The group of four Panthers on a Chippewa fiber *Panel Bag* (fig. 4) is clearly intended to represent two Panther families. Inside the bodies of the two females in the top row are small "baby" manitos, while their larger horns identify the lower two panthers as males. The representation of the Underworld manito on a Sauk and Fox fiber

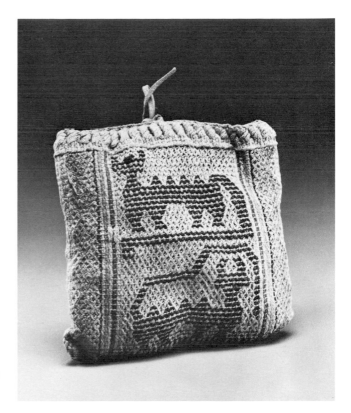

Panel Bag (fig. 8) has highly unusual
branched deerlike horns, although the
other iconographic features are those of
the Underwater Panther. Images of
Underwater Panthers, like Thunder-
birds, are usually accompanied by
zigzag, wavy, or castellated lines, which
have been interpreted as representing
the roiled waters these manitos create.
One Menominee informant also identi-
fied variants of the castellated line as
representations of serpents, often
thought to be the guardians and com-
panions of the Panthers: "It is said that
sorcerers sometimes had representations
of horned serpents woven into the bags
which contained their poisons."[20]

Bags like those we have been examining,
which bear depictions of Thunderbirds
and Underwater Panthers on opposite
sides, may be regarded as a classic type
of fiber panel bag. Occurring in all
major collections and frequently large
and finely made, they can be used as a
baseline for interpreting the imagery of
the genre as a whole. Such bags seem to
constitute models displaying the arrange-
ment of zones of power in the universe.
Images are placed on the two sides of
the bag, establishing a symbolic identity
of one side with the Upperworld and the
other side with the Underworld. Con-
tained between the two surfaces are
power objects or medicines that are
effective on the earth itself, which is
located in the interface between the
Upper- and Underworlds. Great Lakes
mythology repeatedly expresses the
opposition and enmity of the Thunder-
birds and the Underwater beings. Yet, as
we have seen, it would be inaccurate to
interpret this opposition as a division
between good and evil. The metaphor of
positive and negative electric charges
might be more useful, implying as it
does a necessary complementarity in
which two opposite poles of force must
be properly aligned in order for a flow

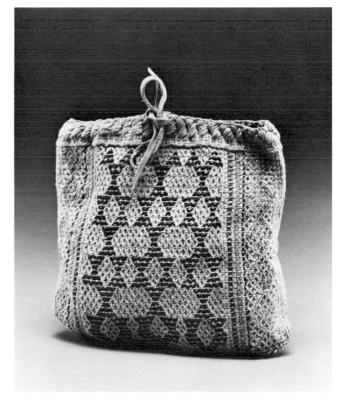

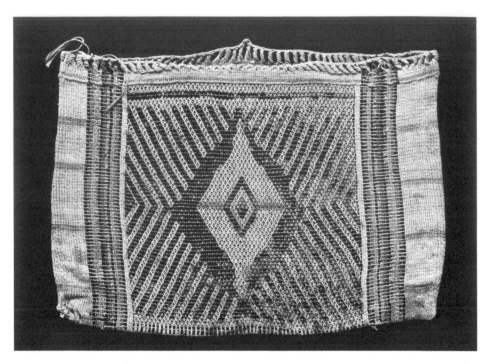

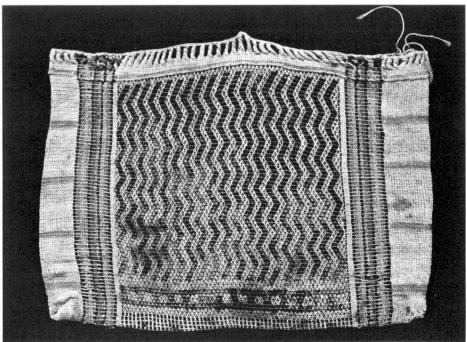

Figure 11.
Panel Bag, obverse,
Chippewa (Wisconsin),
1860; wool, 39.8 x 53 cm
(15½ x 20⅞ in.).
Founders Society
Purchase (81.285).

Figure 12.
Reverse of *Panel Bag*,
figure 11.

60

of energy to be established. The asymmetrical distribution of imagery on twined bags, in which top and bottom, over and under surfaces were differently marked, was perhaps a means of mimetically bringing opposing force fields into balance and neutralizing the destructive capabilities of each.[21]

Dreams and designs

To understand this process more precisely, it is necessary to look at the purpose of manito representations in Great Lakes art. Most discussions of spirit images in the art of this region stress that an image of a manito "is a prayer to gain the protection of these deities."[22] The impetus for making such an image in beadwork, weaving, painting, or sculpture came from a dream or vision. In earlier times images of dream guardians were woven by the Menominee into mats used to line the interiors of houses; in the twentieth century it has been reported that "the most common manner of weaving a dream representation was in woven beadwork."[23] Men who had such dreams would ask their wives to include certain motifs in the beadwork done for them.[24]

The images thus perceived and translated into works of art were not, however, merely decorations or marks of prestige. Stories are related of the transfer of special powers to the possessor of a dream representation. One informant's grandfather had received a Thunderbird vision and wore beaded garters with images of the manito. These garters conferred magical protection and when worn their owner "was imbued with the power of the birds they represented and was able to call lightning from the skies to strike his foes."[25] The powers inherent in vision-derived imagery are thus comparable to those attributed to Plains Indian shield paintings. Indeed, Sauk and Fox informants remarked on this analogy, claiming that their medicine bundles, many of which contained ornamented twined bags, were more powerful than the shields of their Plains neighbors.[26] Other accounts describe the efficacy of objects painted with dream imagery in healing rituals.[27] A story of a Winnebago man who wanted to receive a vision of Earthmaker (see note 15) also increases our understanding of dream representa-

tions. The deity revealed itself as a flash of light and the making of an image was an immediate response: "Then Wegi'cika tried to draw a picture of the flash of light extending from the heavens to his camp, just as he had seen it, upon a cane. To that cane he sacrificed."[28] Thus, the making of an image, the act of prayer through offering, and the retention of the blessing are interrelated acts fundamental to the relationship between man and the powers of the cosmos.

Geometric motifs

It is significant for our discussion of artistic imagery that in the anecdote just cited the image of Earthmaker is described as a non-figural motif. Deities did not always manifest themselves as zoomorphic or anthropomorphic beings. Thus, dream representations could be either non-figural (geometric) or representational. According to one report, one complex dream representation painted on a man's blanket carried both representational and geometric motifs symbolizing the Thunderbird, lightning, and the earth. Although people in the community knew the subject of the dream, "the relation of these (images) to one another and to the dreamer remained a secret known only to himself and those to whom he revealed it." Representation of a dream thus "took the form of an object or an outline, and might be either an exact representation of an article or an outline more or less remotely suggesting a peculiarity of the dream."[29] The semi-hidden meaning of motifs in Winnebago woven bags can be seen as "representations of moods and feelings in the weaver's life," according to one observer. It also appears that "many of the woven bags have designs of the weavers' inspirations during fasting in their first menses periods."[30]

All of this evidence leads to the conclusion that non-representational motifs in weaving, as in other Great Lakes artistic contexts, can be symbolic as well as decorative. If we return to the iconography of the fiber panel bags, we find that many of the older bags display abstract designs either on one or both sides. Beyond a general assertion that these non-representational designs can be seen as an "interpretation" of a phenomenon perceived in a dream rather than an

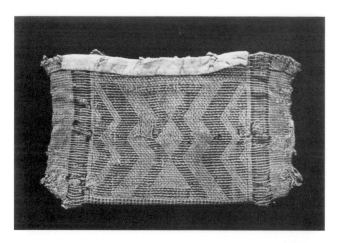

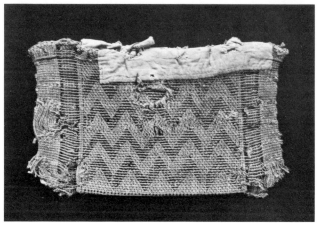

Figure 13.
Panel Bag, obverse,
Potawatomi (Wisconsin),
c. 1870; wool and nettle
fiber cord, 26.7 x 45.7
cm (10½ x 15 in.).
Founders Society
Purchase (81.102).

Figure 14.
Reverse of *Panel Bag*,
figure 13.

represent the stylized serpents reputed to be the companions and guardians of the Underwater Panther. We have already observed the placing of geometric motifs similar to these adjacent to images of the Upper- and Underworld manitos in order to represent emanations of power. Manitos were understood to manifest themselves through aural phenomena, climatic disturbances, and as transformations of the natural landscape.[32] The display of geometric motifs on one side of a twined bag bearing the image of the manito on the other would logically seem to represent an alternative manifestation of the spirit's power perceived as waves of light, sound, or movement. On these smaller bags, then, abstract patterns appear to reinforce and extend the meaning of the explicit image. As containers for individual personal medicines or as component parts of larger bundles, they seem to express the power of a single dream experience rather than the broader ordering of cosmic forces suggested as an interpretation of the "classic" fiber panel bag.

The last group of fiber panel bags to be considered displays abstract designs on both sides. These designs are closely related to the geometricized, conventionalized stylizations of the manitos we have previously discussed. On a Chippewa fiber *Panel Bag* (figs. 11 and 12), the design on the obverse consists of concentric diamonds bordered by radiating patterns of chevrons. The pattern, sometimes termed a "spider-web design," closely resembles an enlargement of the central portion of a Thunderbird image —a "blow-up" of the heart and upper torso. The reverse of this bag with its waves of parallel zigzag lines evokes lightning or, alternatively, water. The contrasting geometric patterns on a Potawatomi fiber *Panel Bag* (figs. 13 and

"imitation," can we penetrate any further their private meanings?

Six additional fiber panel bags, not illustrated here, in the Chandler/Pohrt collection display Thunderbird images on one side and abstract patterns on the other. Most of these bags are small and form component parts of medicine bundles. Close examination of these bags shows a series of recurrent geometric patterns that are related to the representational motifs we have been discussing. In four examples in this group, parallel zigzag lines occur on the reverse side of each bag. On the other Thunderbird bags, hourglass shapes and patterns of concentric squares or polygons are seen on the reverse.[31]

Another bag (figs. 9 and 10) with two Panthers on one side also has a geometric pattern on the reverse composed of two rows of linked star forms terminating in hornlike projections. These apparently abstract shapes could

14) also make use of motifs derived from fully representational manito depictions. The obverse displays an elongated serpentine form composed of lozenge and triangle forms, an enlargement of the form found adjacent to one Underwater Panther depiction (see fig. 6). Additional undulating lines are placed on either side of the central form. The reverse of the bag exhibits a pattern of horizontal zigzag lines which could refer, as in the previous bag, either to lightning or to water. An important aspect of the overall composition of this and other entirely geometric fiber panel bags is the way in which the spatial orientations of the patterns pull in opposite directions when the two faces, or sides, are superimposed. Just as the explicit imagery of bags with an Underwater Panther and a Thunderbird on opposite sides creates a conceptual equilibrium, bags with abstract designs frequently display patterns oriented at ninety-degree angles to each other on their two faces so that the layering of the patterns creates a stable, interlocking grid as seen on the Potawatomi example. Though visually separate, the two faces of the bag form a conceptual unity that is a matrix of positive and negative charges.

So far we have confined our examination to the older type of fiber panel bag. If we now turn to the innovative banded woolen bags that came to replace the fiber panel type, we find that nearly all the geometric motifs they display are immediately identifiable with the design elements that compose images of the cosmic manitos. Hourglass forms occur frequently, as, for example, in a Chippewa *Banded Bag* (figs. 17 and 18), and would seem to be derived from the Thunderbird torso stylizations we have examined. Another element of the Thunderbird image, the fringed diagonal line of the feathered wing, is one of the most common motifs seen on banded woolen bags (see figs. 15 and 18). Bands of parallel zigzag lines and lattices of diamonds (see fig. 16) are also frequently found and closely resemble the abstract designs on the older type of bag.

Although the derivation of the geometric motifs on banded woolen bags from the older fiber panel bags is relatively easy to determine, there remains a funda-

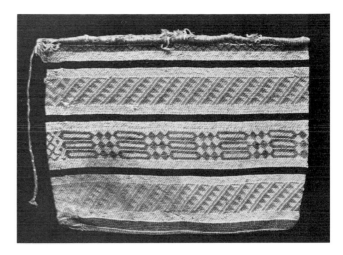

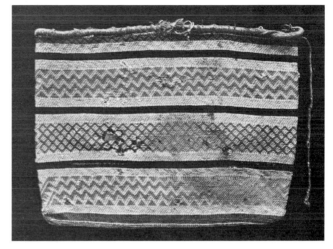

Figure 15.
Banded Bag, obverse, Ojibwa (Wisconsin/Minnesota), c. 1885; wool, 44.6 x 59.7 cm (17½ x 23½ in.). Founders Society Purchase (81.184).

Figure 16.
Reverse of *Banded Bag*, figure 15.

mental problem of interpretation. Are we to regard this late development in Great Lakes art as a shift from the symbolic to the "aesthetic," or to what has been called the "degenerate geometric?" We have already cited early twentieth-century ethnographic evidence that weavers found inspiration in their own visionary experiences and in those of their relatives. In addition, further evidence exists of the use of highly stylized and abstract geometric forms in other late nineteenth-century Great

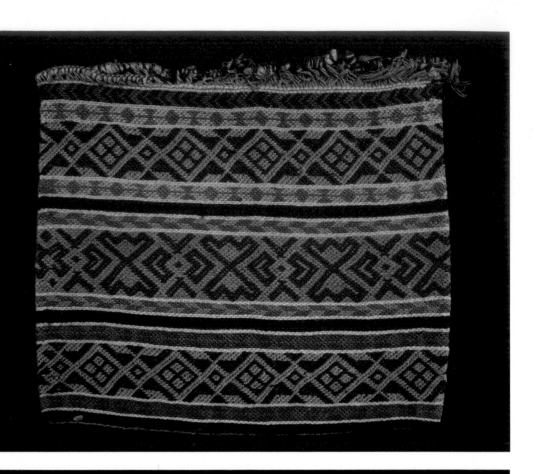

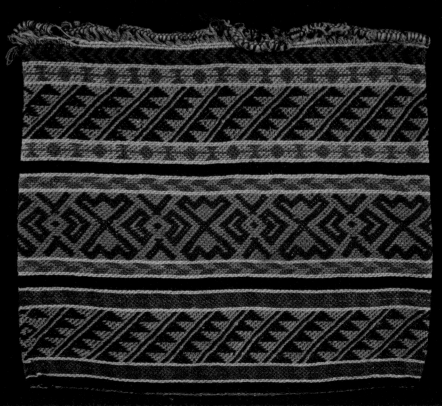

Figure 17.
Banded Bag, obverse,
Chippewa (Wisconsin/
Minnesota), 1890; cotton
and wool, 46 x 51.1 cm
(18⅛ x 20⅛ in.).
Founders Society
Purchase (81.666).

Figure 18.
Reverse of *Banded Bag*,
figure 17.

Figure 19.
Drumstick Bag,
Chippewa (Wisconsin),
c. 1890; wood, otter fur,
wool and cotton cloth, and
braid, 60 x 8.9 cm (23½
x 3½ in.). Founders
Society Purchase
(81.522.1).

Figure 20.
Awl, Chippewa (Walpole
Island, Ontario), c. 1870;
iron and deer antler, 13 x
4.8 cm (5⅛ x 1⅞ in.).
Founders Society
Purchase (81.108).

Figure 21.
Mat Needles, Potawatomi
(Wisconsin), c. 1860;
buffalo rib and wood, l.
32.4 and 27.3 cm (12¾
and 10¾ in.). Founders
Society Purchase
(81.380.1-3).

Lakes art that can be assumed to be related to dream experience. The Chandler/Pohrt collection contains three such objects that exemplify extreme stylizations verging on abstraction. An appliquéd Chippewa *Drumstick Bag* (fig. 19) has on one side a row of linked diamonds resembling the serpentine motif seen in the Potawatomi *Panel Bag* (fig. 13) and displayed on a number of banded woolen bags in other museum collections. Above this motif is a diamond enclosing a square, a motif associated with the earth and the four cardinal points of direction. On top is a figure reminiscent of stylizations of anthropomorphic spirits found on rock art. A second object that displays designs closely related to those on banded woolen bags is a Chippewa *Awl* (fig. 20) incised with three geometric motifs placed beneath a carved spirit face. A lightning/sky motif of vertically oriented parallel zigzag lines is placed at the top, an earth symbol of a diamond enclosing a cross is in the center, and horizontal parallel zigzags evocative of water and serpents are placed at the bottom.[33] Finally, a pair of Potawatomi *Mat Needles* (fig. 21) provides evidence of a degree of stylization equivalent to that seen on late woven bags. The carved forms of the needles suggest representa-

tions of manitos. The wavy contour of one form recalls serpentine imagery, while the notched triangle of the other may derive from a partial contour of the Thunderbird torso, which commonly includes an edging of small triangles along one side, or from a Panther head similar to the representation on the Ottawa *Panel Bag* (fig. 2).

The drumstick, the awl, and the mat needles seem to display a private and personal form of symbolic imagery. These three objects are tools whose efficacy can be extended through the blessings of the spirits. Indeed, all three present stylized images of spirits juxtaposed with geometric designs, providing further evidence that such motifs are symbolic rather than decorative. In all three cases a vertical stacking of the geometric motifs occurs that parallels the way in which bands of related geometric motifs are stacked on the late-period banded woolen bags. Although the contrasted patterns are still seen on the two sides of these later bags in approximately half the examples examined, a new kind of spatial zoning has been introduced in the horizontal division of the bag face. We might think of this change in terms of a shift from a

66

three-dimensional model of the cosmos to a two-dimensional map. The classic fiber panel bags, we have suggested, replicated the structure of Upperworld/earth surface/Underworld as obverse/contents/reverse. The banded woolen bags appear to present a more idiosyncratic and personal charting of zones of spirit power on the two-dimensional surfaces of the individual bag face.

The changes that occurred in the design of woven bags during the nineteenth century were closely paralleled by changes in other forms of art. The shift from a combination of unambiguous representational imagery and geometric design to esoteric abstract patterning that occurred in woven bags also took place, for example, in shoulder bags from the Great Lakes. The quill-embroidered hide bags of the late eighteenth century with their clear images of Thunderbirds and Panthers were replaced by the geometric and floral motifs of beaded bandolier bags. In these bags, too, there may be a greater weight of symbolic intention than is usually assumed.[34] It seems highly unlikely that the expressive meaning of Great Lakes Indian art could have changed so totally and so suddenly under the stimulus of new materials and stylistic approaches when we know that traditional religious ideas and cosmology were still retained. Rather, visual analysis suggests that an ancient repertory of geometric motifs, which had long been used to communicate the immaterial manifestations of the manitos, continued to be employed. Although the syntax changed, the vocabulary remained intelligible. During the nineteenth century, in the medium of twined bags, Great Lakes Indian artists continued to find in dreams the ancient designs of cosmic power.

Notes

1.
This essay is based on a comparison of the Chandler/Pohrt collection bags with approximately 225 other specimens examined at first hand in the American Museum of Natural History, New York; the Milwaukee Public Museum; the Field Museum of Natural History, Chicago; the National Museum of Man, Ottawa; the Glenbow Museum, Calgary; the Royal Ontario Museum, Toronto; the National Museum of Ireland, Dublin; the British Museum, London; and the Museum für Volkerkunde, Vienna. In addition, published examples from a number of other collections are referred to. I am grateful to the Social Sciences and Humanities Research Council of Canada for supporting this research.

2.
B. F. Carter, "The Weaving Technic of Winnebago Bags," The Wisconsin Archaeologist 12, 2 (1933): 34.

3.
For information and photographic documentation on Menominee bags and their manufacture, see A. Skinner, "Material Culture of the Menomini," Indian Notes and Monographs 18 (1921): 5-216. On the Chippewa, see F. Densmore, "Chippewa Customs," Bureau of American Ethnology Bulletin 86 (1929), and C. Lyford, "The Crafts of the Ojibwa," Indian Handcrafts 5 (1943). On the Winnebago, see Carter 1933 (note 2): 33-45. Most recently, A. Whiteford has provided a thorough discussion of the subject, including a useful terminology for classifying the different types of bags (which I have followed), a detailed analysis of twining techniques, and an investigation of the historical development of finger weaving in the region ("Fiber Bags of the Great Lakes Indians, I," American Indian Art Magazine 2, 3 [1977]: 52-64, 85 [hereafter referred to as "1977a"]; "Fiber Bags of the Great Lakes Indians, II," Ibid., 3, 1 [1977]: 40-47, 90 [hereafter referred to as "1977b"]; and "Tapestry-Twined Bags, Osage Bags and Others," Ibid. 3, 2 [1978]: 32-39, 92).

D. Burnham's briefer discussion ("Textile Traditions of the Native People," The Comfortable Arts, Ottawa: National Gallery of Canada, 1981) contributes further diagrams and technical details.

4.
An overall discussion of bird and feline images in Great Lakes art, including those on woven bags, is provided by L. Wilson, "Bird and Feline Motifs on Great Lakes Pouches," in Native North American Art History, eds. Z. Pearlstone Mathews and A. Jonaitis, Palo Alto, California, 1982: 429-444. See also Penney and Stouffer, "Horse Imagery in Native American Art," pp. 18-25.

5.
The earliest extant examples of fiber panel bags probably date to the mid-eighteenth century. Three bags now in the National Museum of Ireland, Dublin (1902.327, 1902.328, and 1902.329), may be the earliest documented examples. They were collected between 1800-09 in the vicinity of Detroit and show signs of wear. Lyford states that "a well made bag would last a hundred years or more" (1943 [note 3]: 77), so that these bags could have been made as early as the mid-eighteenth century. Very few other examples occur in early European collections, although there are two in Vienna and two in the British

Museum on loan from Stoneyhurst College, which were collected in the mid-nineteenth century. Whiteford points out that similar weaving techniques were in use as early as the first millenium in the Great Lakes region (1977a [note 3]: 36).

6.
Whiteford's statement about the period when the change occurred in the Great Lakes is slightly unclear (1977b [note 3]: 40), and he does not cite his evidence for putting the origin of the banded woolen bags back to the mid-eighteenth century. I am not aware of any museum specimen that could be dated this early.

7.
Whiteford 1977b (note 3): 40.

8.
Carter 1933 (note 2): 45. On the Menominee, see Skinner 1921 (note 3): 257.

9.
Wilson 1982 (note 4): 441.

10.
A. Hallowell, "Ojibwa Ontology, Behavior, and World View," reprinted in *Primitive Views of the World*, ed. S. Diamond, New York, 1976: 370.

11.
P. Radin, "The Winnebago Tribe," *Thirty Seventh Annual Report of the Bureau of American Ethnology 1915-1916* (1923): 287.

12.
Skinner 1921 (note 3): 265.

13.
Ibid: 261.

14.
Densmore 1929 (note 3): 82.

15.
On the Chippewa, see Densmore 1929 (note 3): 82. On the Winnebago, see Radin 1923 (note 11): 288. Unlike the Chippewa, the Winnebago appear to have had a concept of a Supreme Creator, usually called Earthmaker, and did not make strict good-evil dichotomies.

16.
V. Barnouw, *Wisconsin Chippewa Myths and Tales and their Relation to Chippewa Life*, Madison, Wisconsin, 1977: 132. G. Hammel finds the same "complementary, bilateral symmetries of Above and Below" in Iroquois mythology, in which the eagle symbolized the sky world and the serpent the Underworld ("Pieces of Dreams and Ancestors: The Tree and Serpent Motifs in Iroquois Culture," unpublished manuscript, n.d.).

17.
Skinner 1921 (note 3): 260.

18.
Ibid.: 263.

19.
Barnouw 1977 (note 16): 139.

20.
Skinner 1921 (note 3): 265. Castellated lines appear in association with Thunderbird images on the Sauk and Fox *Panel Bag* (fig. 7), where they could also be interpreted as the bottom half of a line of linked hourglass Thunderbird torsos. For a discussion of the intentional ambiguity of such imagery, see R. Phillips, "Zigzag and Spiral: The Interpretation of Geometric Design in Great Lakes Indian Costume," *Papers of the Fifteenth Algonquian Conference*, ed. W. Cowan, Carleton University, Ottawa, 1984.

21.
T. Michelson notes that the myths of many Woodlands peoples narrate conflicts between Thunderbirds and water monsters in which the manitos ask and receive help from humans ("Contributions to Fox Ethnology—II," *Bureau of American Ethnology Bulletin* 95 [1930]: 55-56). These narratives also reflect three cosmic power "zones," sky-Thunderbirds/earth-man/Underworld-water spirits.

22.
Skinner 1921 (note 3): 261.

23.
Ibid.: 241; and Densmore 1929 (note 3): 82-83.

24.
For a similar practice among the Naskapi, see F. Speck, *Naskapi*, 3rd ed., Norman, Oklahoma, 1977: 199.

25.
Skinner 1921 (note 3): 259.

26.
M. Harrington, "Sacred Bundles of the Sac and Fox Indians," *The University Museum Anthropological Publications* 4, 2 (Philadelphia, 1914): 133.

27.
Densmore 1929 (note 3): 82.

28.
Radin 1923 (note 11): 293.

29.
Densmore 1929 (note 3): 82 and pl. 32(b). The Chandler/Pohrt collection contains a twined Sauk and Fox *Bag* (81.531) displaying a juxtaposition of representational and geometric forms very similar to the blanket described by Densmore.

30.
Carter 1933 (note 2): 45.

31.
These bags are 81.392, 81.399, 81.433a, and 81.433b (parallel zigzags), 81.103 (hourglass forms), and 81.367 (concentric squares).

32.
Hallowell 1976 (note 10): 370-372.

33.
Radin identifies the cross as a symbol of Earthmaker in the context of the war bundle feasts and says that it is "unquestionably supposed to represent the four cardinal points" (1923 [note 11]: 28).

34.
Phillips 1984 (note 20).

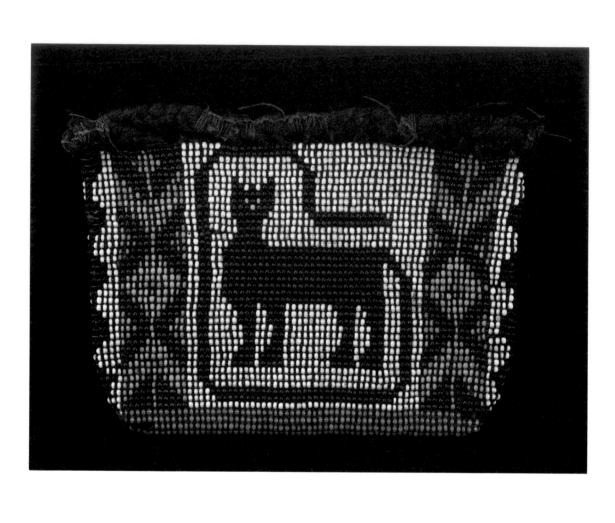

Beaded Twined Bags of the Great Lakes Indians

Nancy Oestreich Lurie

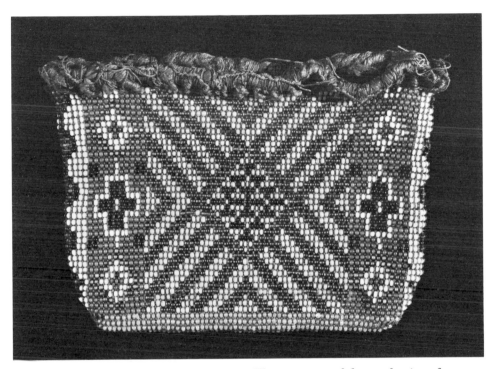

Figure 1 (opposite).
Bag, obverse, Sauk and
Fox (Tama, Iowa),
c. 1880; beaded twined,
split warp, one-stick
technique, 9.8 x 13.7 cm
(3⅞ x 5⅜ in.). Founders
Society Purchase (81.352).

Figure 2.
Reverse of *Bag*, figure 1.

Although fiber bags made by the Great Lakes Indians and neighboring tribes of the Prairie area such as the Iowa and Osage are relatively well documented[1] (see Phillips, "Dreams and Designs: Iconographic Problems in Great Lakes Twined Bags," pp. 52–69), one variation, the beaded bag, has not been studied in detail. The dozen examples of such bags in the Chandler/Pohrt collection at the Detroit Institute of Arts present an opportunity to look systematically at this type of bag.

Three aspects of the production of beaded bags are clear: their geographic spread, temporal span, and physical size. The incorporation of beads in the fiber bag technique was widely diffused among the Great Lakes tribes, including those still resident in their homelands and those removed west by the government. The Chandler/Pohrt bags come from the Wisconsin Winnebago, the Sauk and Fox[2] of Iowa, the Ottawa and the Potawatomi of Michigan, and the Kansas Kickapoo[3] An outstanding example of the beaded twined bag is a Sauk and Fox *Bag* (figs. 1 and 2) embodying the classic stylized features of a Thunderbird on one side and an Underwater Panther on the other. The decorated panels are framed with both dyed warps and vertical patterns of beading.

The beaded bags appear to have been made for only a short time, primarily during the decade 1870-80 and certainly

71

no later than the end of the nineteenth century, judging by the absence of the vividly colored opaque glass beads that were introduced and became popular after about 1900. All the beaded bags are small, usually measuring 7.5 by 10 centimeters (3 by 4 inches) or less, with the largest about 15 by 20 centimeters (6 by 8 inches). Although similar bags without beads also may be as small as the beaded ones, many are 28 by 35 centimeters (12 by 15 inches) or larger. The painstaking effort required in the production of the beaded examples may explain their small dimensions.

The wide geographical distribution of these bags and the short period of their recorded production could suggest that this type of beading posed both technical and aesthetic challenges which, once met, lost their fascination. The same overall effect can be achieved with much less effort and time by making a length of loom beading and sewing up the sides to form a small bag, as is still done to make the beaded coin purses that are largely sale items for tourists. (The older beaded twined bags are considered treasured personal items.) In fact, the bags under discussion here are easily mistaken for loomed beading, as indicated by their erroneous description as such when they were originally catalogued by the Detroit Institute of Arts and other museums. Their remarkable workmanship has gone unrecognized even in exhaustive reference works on Indian beadwork.[4]

Prototype bags

In order to appreciate fully the adaptive ingenuity involved in producing these small beaded bags, it is useful to review briefly the original beadless prototype bags.[5] Although often referred to as woven, these bags are in fact twined because they are not made on a loom. There are two basic types of twined bags: those made in the one-stick and those made in the two-stick technique. Using the one-stick technique (fig. 3a), a stiff, slender stick is suspended horizontally by a cord attached to the ends. Warps are hung over the stick, extending to an equal length on each side. The mid-points of the warps resting on the stick form the bottom of the bag. The weft is a continuous double strand enclosing each warp and is secured by a

twist between warps (fig. 4a). Twining begins along the top of the stick at one end and progresses to the other end before it spirals around the warps, thus producing a seamless bag. The left end is the usual starting point with the weft spiraling in a clockwise direction.[6] When the bag is completed, the stick is easily slipped out. The ten centimeters or so of loose warp remaining beyond the completed bag are gathered into bunches and worked into a continuous braid to finish off the bag. The braid may begin either tight against the top of the bag or about a centimeter or less above the twining so the warps give a lattice effect between the braid and the bag proper.

The two-stick technique (fig. 3b) uses two fairly sturdy sticks stuck in the ground or inserted in a board as far apart as the desired width of the bag. A heavy cord is tied to encircle the tops of the sticks. The hanging warps are attached at their mid-points close together along the top cord with larkshead hitches. Twining begins tight against the line of hitches with a continuous double weft and progresses in a downward spiral as in the one-stick bags. The result is a seamless tube patterned with colorful, horizontal bands in a variety of geometric and occasionally pictorial designs which differ on each side of the bag. The row of hitches becomes the bottom of the bag; this is sewn shut when the completed bag is taken off the sticks. The top is finished off with a braid as in the one-stick bags. A typical two-stick bag is shown in a Chippewa example (fig. 5). On two-stick bags the braid is almost always covered over with buttonhole stitching in thread or yarn or, occasionally, with a strip of cloth sewn over the braid. The two-stick technique is more recent and seems to have come into vogue with the greater availability of commercial yarn. In the examples from the nineteenth century, raveled and re-spun blanket yarn is frequently used. The beaded bags in the Chandler/Pohrt collection are made by the one-stick technique,[7] but in some cases the top edge is finished off with buttonhole stitching over the braid as in many of the two-stick bags. An Ottawa beaded twined *Bag* (figs. 9 and 10) is one such example. Although the bag was made with the one-stick technique, it

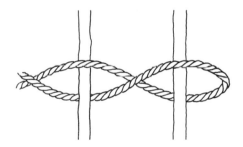

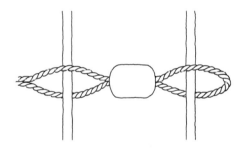

Figure 3a (top left).
One-stick technique.

Figure 3b (top right).
Two-stick technique.

Figure 4a (bottom left).
Simple twist of two-
strand weft-enclosing
warps.

**Figure 4b (bottom
right).**
Bead substitute for twist
of two-strand weft.

resembles the patterns used on two-stick yarn bags.

Large storage bags provide the most easily understood examples of one-stick bag technique. The warps are simply narrow hanks of softened fiber, such as apocynum, nettle, or the inner bark (bast) of basswood saplings, and the weft is a double strand of basswood or other natural fiber twisted into two-ply twine. The successive rows of weft are a centimeter or farther apart as they spiral down around the bag. Some or all

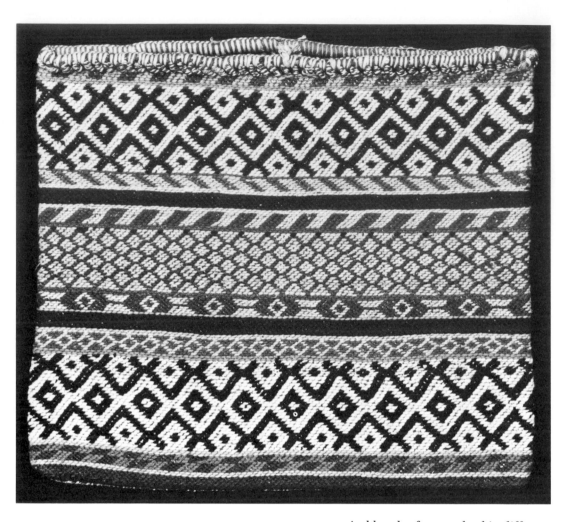

Figure 5.
Bag, Chippewa
(Michigan), c. 1890;
yarn, two-stick
technique, 45 x 49.5 cm
(17¾ x 19½ in.).
Founders Society
Purchase (81.90).

of the warps are dyed different colors,
producing patterns of vertical stripes on
the bags (see fig. 6).

In some of the one-stick fiber bags the
warps are paired and alternately divided
in each successive line of the weft,
creating a pattern of X's rather than
straight vertical lines of warps. This
technique figured importantly in
another distinctive type of bag that
employed the one-stick technique and
strongly influenced the beaded bags.
Termed "panel bags" because each side
of the bag is treated as a separate design
panel and is usually framed between

vertical bands of warps dyed in different
colors, these bags are tightly twined with
the spiraling weft rows close together, as,
for example, a Potawatomi *Panel Bag*
(see Phillips, figs. 5 and 6). Another
complication (also found in the later
two-stick yarn bags with some inter-
esting variations) is that the two strands
of the weft are often different colors so
that the desired color is brought to the
surface of the bag by a single or double
twist of the weft strands. When
commercial string and yarn became
available through trade in the nine-
teenth century, these materials were
substituted in whole or in part for the
Indian-made cordage of vegetable fiber
and animal hair, particularly bison hair,
but they did not change the highly
distinctive overall appearance of the
panel bags. The warps are predomi-
nantly beige, varying in shade from gray
to cream, with the designs in the panels
worked in dark brown wefts. The
vertical bands, made up of dyed warps

that frame the sides of the panels, are usually red, but may include dark blue, green, yellow, and other colors.

Beaded bag technique

The beaded bags were patterned after the simple straight warp technique of the vertically striped apocynum bags, but with the weft rows close together. In their decorative elements, however, they generally mimic the panel bags, which have different designs on each side in framed panels. This is a marked contrast to the vertically striped, one-stick fiber bags, which are the same on both sides, and the two-stick yarn bags, which, though different on each side, have horizontal stripes. The decorative development of the beaded bags out of the panel bags is further evident in the fact that some of the beaded bags, like the panel bags, have vertical bands of dyed warps framing the panel. Framing also is suggested in vertical patterns of distinctively colored beads instead of dyed wefts. Only one *Bag* (figs. 9 and 10) in the collection is suggestive of the pattern of horizontal stripes found on the two-stick yarn bags. All of the Chandler/Pohrt beaded bags have different patterns on the two sides.[8]

As in the case of the panel bags, both geometric and pictorial designs are found on the beaded versions. A popular pairing of panels consists of Thunderbirds and long tailed, horned Underwater Panthers, as seen on the Potawatomi example, but horses, deer, and occasionally human figures also are shown. Some bags have a pictorial design on one side and a purely geometric pattern on the other, or both sides have geometric designs that may differ in pattern or color combination. Seven of the Detroit beaded bags have geometric patterns on both sides, two have pictorial designs on both sides, and three combine pictorial and geometric sides.[9]

While the panel bags were the obvious model for the design motifs on the beaded bags, the latter are more colorful, thanks to the variety of shades available in beads and the fact that the artisan was not confined to two colors in the double weft. The two-stick yarn bags incorporate many innovative techniques in alternating colors in both the warp

Figure 6.
Storage Bag, Ottawa (Michigan), c. 1890; apocynum fiber, one-stick technique, 32.4 x 50.2 cm (12¾ x 19¾ in.). Founders Society Purchase (81.84).

and weft, but the beaded bags were confined to the model of the simpler handling of these elements in the one-stick storage and panel bags. For all that, the use of color and the complexity of patterns in the beaded bags are impressive, particularly in pictorial designs of irregular forms such as Panthers (see fig. 1). These must have been difficult to produce even in the unbeaded bags because the picture was viewed upside down while the bag was being made.[10]

The basic technique for the beaded bags substitutes beads for the twists of the double strand weft used between the straight warps of the one-stick bags (fig. 4b). While this is easily said, it required enormous patience and dexterity to slip the double weft through each bead! It is probable that all the beads making up one row were arranged in their intended order of colors on the double weft in advance, and the warps were then slipped through the double weft between the beads rather than bringing the weft strands around each warp and adding beads one at a time in lieu of twists. Such lining up of beads in advance is employed in loomless, diagonal beading to produce long, two-centimeter (one-inch)-wide strips of patterned beading for pendants on women's hair ornaments in the Great Lakes area and would seem to offer a logical model in the beading of twined bags. Having the beads in a row on the weft also would allow the artisan to check her pattern row by row and, if necessary, correct errors before a row of

75

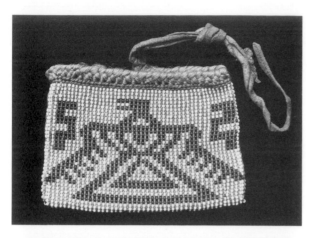

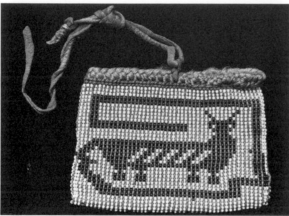

Figure 7.
Bag, obverse, Winnebago
(Wisconsin), c. 1870;
beaded twined, one-stick
technique, 6 x 8.6 cm
(2⅜ x 3⅜ in.). Founders
Society Purchase
(81.368).

Figure 8.
Reverse of *Bag*, figure 7.

the impression that they were made by a different technique than the sides, which usually are made of darker, more opaque beads. Microscopic inspection makes clear, however, that the beaded bags were begun on a single suspended stick, in the same manner as the unbeaded fiber bags.

A second puzzling feature is revealed when the twelve beaded Chandler/Pohrt bags are compared to ordinary fiber bags. Virtually all of the apocynum bags (see fig. 6) and most of the panel bags (see Phillips, figs. 5 and 6) tend to curve outward slightly at the sides. Whether this was the result of an over-compensation for a tendency to pull the wefts in too tightly, which would produce a bag with inward curving sides and limit its capacity, or the natural result of working with loose warps is unknown. Whatever the reason for the curve, it appears to have been con-sidered either aesthetically necessary or somehow important from a practical point of view since some bag makers took special measures to create it.

Simply substituting unyielding beads for the weft twists would have resulted in a straight-sided bag. That is the case with a few of the bags, each of whose sides is defined by a single vertical line of beads between two warps, just as the flat sides are made up of parallel lines of beads between warps. Most of the beaded bags, however, show a slight outward curve of the sides that required ingenuity bordering on fudging to achieve. In such bags, a single vertical line of three or more beads extends up the edge from the bottom; it then branches into three vertical lines of beads extending up the edge and may branch again into five lines. An exception is found in one Winnebago *Bag* (figs. 7 and 8) where the single vertical line of beads along the

beads was firmly secured between the warps.

This is a persuasive explanation as to how designs were produced expeditiously on the sides of the bags, but getting the first rows started along the bottom of the bag must have been extremely difficult because one would have had to start with loose warps and wefts. Examination with both the naked eye and a magnify-ing glass suggests that the difficulty was overcome by beginning the bottom with a strip consisting of a few rows of loom beading, which was then removed from the loom and laid along the length of the single stick. The dangling loom warps on either side then served as bag warps.[11] Contributing to the false surmise that a bead loom might have been involved in the beginning step is the fact that the three or more rows of beads along the bottoms of the bags usually are very different in color and even use a different style of bead (frequently opalescent) than those used on the sides of the bags. The bag bottoms thus give

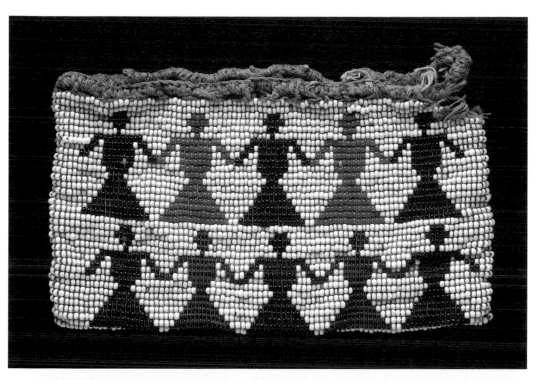

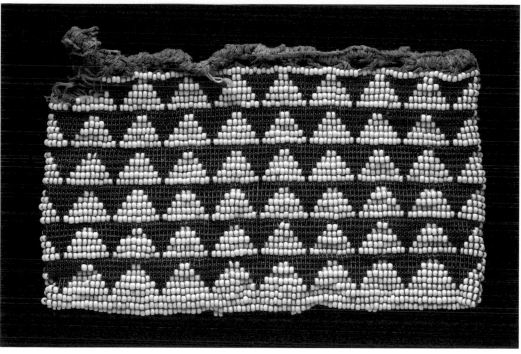

Figure 9.
Bag, obverse, Ottawa
(Michigan), c. 1870;
beaded twined, one-stick
technique, 7.8 x 12.9 cm
(3¹/₁₆ x 5¹/₁₆ in.).
Founders Society
Purchase (81.282).

Figure 10.
Reverse of *Bag*, figure 9.

Figure 11.
Charm Bag, obverse,
Potawatomi (Wisconsin),
c. 1880; beaded twined,
one-stick technique,
6.7 x 8.4 cm (2⅝ x 3½
in.). Founders Society
Purchase (81.362).

Figure 12.
Reverse of *Charm Bag*,
figure 11.

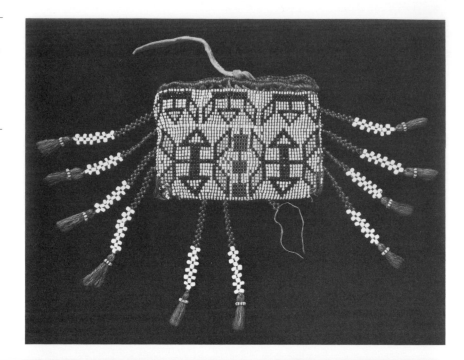

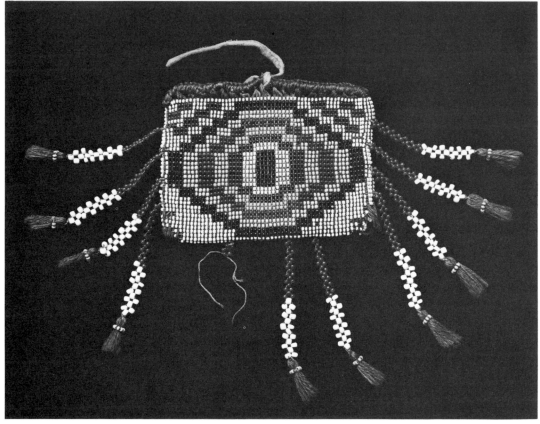

Figure 12a.
1-3-5 . . . pattern of
branching lines of beads
along edge of bag.

Figure 12b.
1-2-6 . . . pattern of
branching lines of beads
along edge of bag.

edge branches to two lines and then to four lines. The number of beads in a vertical line before it branches and the number of branches depend on the size of the bag, but the outward curve is proportioned as in the fiber and panel bags showing such curves. That the curve was desired is indicated by the two different methods employed to create the 1-3-5 . . . or 1-2-6 . . . increases (figs. 12a and 12b).

The usual technique in the Chandler/Pohrt examples was to split the warp, which resulted in the 1-3-5 . . . lines of beads in the branches (see figs. 1 and 2). Both the warps and wefts of these beaded bags appear to be entirely of commercial origin and are finer than even the commercial cordage in ordinary panel bags. In the beaded bags, the warps are almost always much coarser than the weft strands, which appear to be

commercial thread. The warp material is usually fiber about the thickness of fine yarn but stiffer. In some of the very small bags it is the same material as the wefts, but twisted into multi-ply strands. In either case the plies could be separated to split the warp.

The alternative method used to achieve a branched increase in the vertical lines of beads along the edges of the bag was to put two beads instead of one on the weft between two warps. The branching then progresses according to the 1-2-6 . . . pattern (see figs. 7 and 8). The slight loosening of the weave that occurs where warps are separated by two beads may have been considered preferable to the risk of weakening the bag fabric by splitting any warps.

An exhaustive review of museum collections probably would reveal the

production of beaded twined bags by additional Great Lakes peoples. A larger sample also would allow study of possible tribal preferences in overall size, type and color of beads, design motifs, and special decorative elements,[12] such as the fringes of narrow loom-beaded tabs with tiny fiber tassels at the ends found on a Potawatomi *Charm Bag* in Detroit (figs. 11 and 12) and on a Menominee example at the Milwaukee Public Museum. While Great Lakes beaded bags are not as abundantly represented in museum collections as unbeaded ones, they are sufficiently common to inspire future research on features other than technique.

Notes

1.
The basic types of fiber bags woven by Great Lakes and neighboring tribes are analyzed in detail by A. Whiteford, "Fiber Bags of the Great Lakes Indians, I," *American Indian Art Magazine* 2, 3 (1977): 52-64, 85; "Fiber Bags of the Great Lakes Indians, II," Ibid. 3, 1 (1977): 40-47, 90; and "Tapestry-Twined Bags, Osage Bags and Others," Ibid. 3, 2 (1978): 32-39, 92. I am also indebted to Whiteford for comments and suggestions he offered in regard to the first draft of this article.

2.
The Sauk and Fox are two tribes that at various periods combined or confederated for strategic purposes. The government chose to assign both groups to a reservation in Kansas under a government appointed chief. A large group of Fox decamped from this group and purchased land near Tama, Iowa, that eventually was recognized as a federal reservation. The Fox prefer to be called Mesquakie.

3.
The collections of the Milwaukee Public Museum contain ten beaded bags: five from the Kansas Potawatomi, four from the Menominee of Wisconsin, and one from the Wisconsin Potawatomi.

4.
W. Orchard, *Beads and Beadwork of the American Indians*, Contributions from the Museum of the American Indian 11 (1975), 2nd ed.

5.
This discussion is based on Whiteford 1977 (note 1) for its categories.

6.
Whiteford's studies (1977 [note 1]) indicate the left is the starting point.

7.
This is true of all examples I have seen.

8.
A Menominee beaded twined bag in the Milwaukee Public Museum has the same pattern on both sides.

9.
All of the Milwaukee Public Museum bags have geometric patterns on both sides.

10.
A two-stick yarn bag in the Milwaukee Public Museum has a row of female figures standing on their heads, apparently because the maker forgot she was working from the bottom to the top.

11.
The difficulty of starting the first row of beading is clearly shown in a Kansas Potawatomi bag in the Milwaukee Public Museum. Here the maker solved the problem by doing the very first weft row along the stick in the standard fiber bag technique, twisting the double weft around the warps, and then substituting beads when she began the spiraling courses of the weft around the warp.

12.
A large sample is especially desirable in order to correct for the possibility that some bags identified according to the tribe where they were collected actually arrived there through intertribal trade or gift exchange.

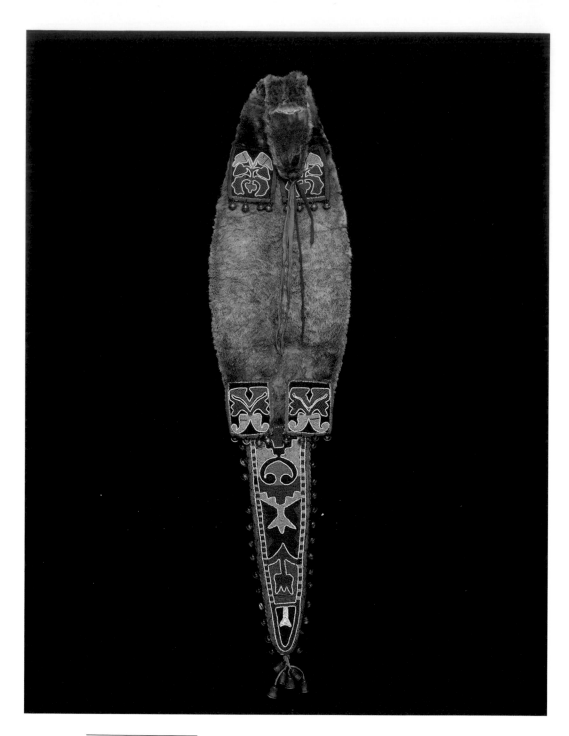

Figure 1.
Midé Bag (Pinjigosaun),
Winnebago, c. 1870;
otter skin, beaded
panels, feathers, and
brass bells and thimbles,
l. 118.1 x w. 23 cm (46½
x 9 in.). Founders
Society Purchase
(81.486).

"He Heard Something Laugh": Otter Imagery in the Midéwiwin

Julia Harrison

The otter, an animal traditionally abundant in the Great Lakes area, has figured prominently in the economic and religious life of the region's Native peoples. Its rich, luxuriant pelt was sought after by fur traders while also playing an integral role in the rituals of the Midéwiwin, or Grand Medicine Society. The Ojibwa and related groups fashioned otter skins into elaborately decorated pinjigosauns,[1] or medicine bags, for use in the Midéwiwin religious rites. The Chandler/Pohrt collection in the Detroit Institute of Arts contains eight fine examples of these otter bags.

A legend found among the Ojibwa of northern Minnesota sheds light on the place of the otter in the Midéwiwin. It relates that the mythical culture hero Nanabozho, known by several names including Mi nabo zho,[2]

saw how helpless they (the Ojibwa) were, and desiring to give them the means of warding off the diseases with which they were constantly afflicted, and to provide them with animals and plants to serve as food and with other comforts, Mi nabo zho remained thoughtfully hovering over the center of the earth, endeavoring to devise some means of communicating with them, when he heard something laugh, and perceived a dark object appear upon the surface of the water to the west. He could not recognize its form, and while watching it closely it slowly disappeared from view. It next appeared in the north, and after a short lapse of time again disappeared. Mi nabo zho hoped it would again show itself upon the surface of the water, which it did in the east. Then Mi nabo zho wished that it might approach him, so as to permit him to communicate with it. When it disappeared from view in the east and made its reappearance in the south, Mi nabo zho asked it to come to the center of the earth that he might behold it. Again it disappeared from view, and after reappearing in the west Mi nabo zho observed it slowly approaching the center of the earth . . . when he descended and saw it was the Otter, now one of the sacred manidos of the Mide'Wiwin. Then Mi nabo zho instructed the Otter in the mysteries of the Mide'Wiwin and gave him at the same time the sacred rattle to be used at the side of the sick; the sacred Midé drum to be used during the ceremonial of initiation and at sacred feasts, and tobacco, to be employed in invocations and in making peace.[3]

Thus the otter was educated in the mysteries of the Midéwiwin and became the intermediary between Nanabozho and the Ojibwa.

The pinjigosauns were used to store medicine, herbs, and other items utilized in the Midéwiwin, the most important Native American religious institution in the Great Lakes area. The pinjigosauns were given to members following their initiation into the society. The Chandler/Pohrt collection includes otter bags from the Potawatomi, Sante Sioux, Fox, and Winnebago. Made from the complete otter pelt with a slit on the underside to provide an opening, the bags feature panels of porcupine quill-work or elaborate beadwork affixed to the paws and tails. Feathers through the animals' nostrils, and bells, thimbles, or cones attached to the tails or paws complete the decorations.

Two Fox pinjigosauns (figs. 2 and 3) are among the oldest examples in the Chandler/Pohrt collection. Dating from about 1850, the two bags feature netted quillwork, one of the oldest forms of quill decoration which was not practiced later in the nineteenth century.[4] A web or network of rawhide was attached to the paws or tails and dyed porcupine

83

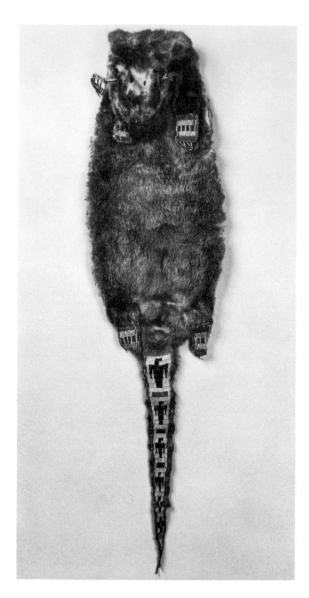

Figure 2.
Midé Bag (Pinjigosaun),
Fox, c. 1850; otter skin,
porcupine quillwork,
feathers, and tin cone, l.
87.6 x w. 17.8 cm (34½ x
7 in.). Founders Society
Purchase (81.303).

quills were wrapped around it to form
the decorations. Each quill was individ-
ually wrapped around a strand of the
netting, with the ends of the quill tucked
up behind itself. Other types of quill-
work are evident in the tail decorations
of the second example (figs. 3 and 4).
The outer edges feature simple multi-
color zigzag bands, while the center
portion is worked in a two-quill

diamond pattern. A zigzag band was
formed by passing the quill back and
forth diagonally between two strands of
stitched sinews. Variations on this
triangular pattern were achieved
through the use of quills of different
colors and widths. The complex two-
quill diamond technique resulted when
two quills were passed back and forth
between two parallel strands of stitched
sinew. The quills were started on
opposite sides of the sinews and crossed
over and under each other.[5] The tail and
rear paws of the animal are fringed with
tin-cone pendants strung on wrapped
buckskin and dyed horse tail fibers.

Spot stitching, a technique also used for
bead appliqué, appears on two Potawa-
tomi pinjigosauns (figs. 5 and 6). Black
buckskin, which had been smoked to
produce a dark color, was used for the
quill tabs found on the paws. The quills
were twisted and then tacked down at
intervals with thread to form the
decorative patterns. Simple zigzag bands
may be seen in the center of the tail on
one of the bags (fig. 6), dating from
about 1860. The bag also features black
buckskin fringes dangling from its paws
and brass thimbles hanging from strings
of glass beads on its tail.

By the latter half of the nineteenth
century, beadwork had begun to replace
quillwork in the decoration of otter
bags. Beads became more available
through trade and proved to be more
durable than the quills. The new
medium provided the Native American
artist a chance to experiment with a new
technique and brighter colors.[6] The
Chandler/Pohrt collection contains two
superb examples of beaded otter bags,
both featuring detailed floral patterns
down the tail. The technique used was
the same spot-stitch method used for
quillwork; beads were strung on thread
and tacked down at intervals. A
Winnebago pinjigosaun (figs. 1 and 8)
from about 1870 features beadwork
appliqué on a coarse, heavy piece of
stroud wool, a fabric obtained through
trade, edged in red silk. The floral
design, in the typical Winnebago colors
of pink, blue, red, green, and yellow is
highly abstract. A Potawatomi
pinjigosaun (fig. 7) from about a decade
later demonstrates the same synthesis of

floral patterns with indigenous Native American designs.

The eyecatching beaded or quilled decorations, worked in vibrant colors, enlivened the appearance of the otter bags. The exact meaning of the designs, if any, however, is not known. Tin cones, bells, and thimbles were often added to the bags to provide an audible dimension when the bags were shaken or rattled during ceremonial occasions. The feathers through the animals' nostrils completed the kinetic effect, moving with each step and gesture made by Midéwiwin members or initiates. Taken as a whole, the brightly colored decorations, tin cones, bells, and feathers served to animate the bag and make the otter seem to come alive.

The Midéwiwin

Contact with European culture, whether through fur trade or immigrant settlers, had a dramatic impact on Great Lakes Native culture and life-style. During the seventeenth and eighteenth centuries, the otter, beaver, and muskrat became valuable trade commodities and thus a source of livelihood, providing the Ojibwa access to the material world of the European traders. By the early part of the nineteenth century, however, the once abundant supplies of these animals had begun to diminish following nearly two centuries of trapping. The Native American subsistence base changed from big game and fish to buffalo in the far western reaches of the territory, and gradually a wage and welfare based economy took its place. At the same time the pace of white settlement quickened with the major land cession treaties of 1837, 1842, and 1854. Epidemics of new diseases caused a drastic decline in the Native population; alcohol addiction grew. Items of European manufacture replaced many traditional items of material culture as the Native peoples became entangled in the European world. Against this background of social change and unrest the Midéwiwin represented an attempt to retain elements of traditional ideology.[7]

Thought to have developed first among the Ojibwa of Minnesota before spreading to the other groups in the region, such as the Potawatomi, Menomimee,

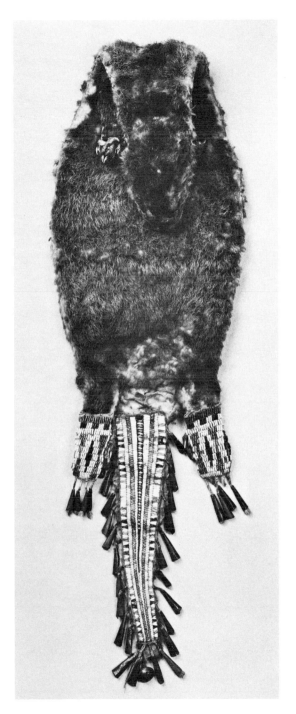

Figure 3.
Midé Bag (Pinjigosaun), Fox, c. 1850; otter skin, quillwork, leather fringe, and tin cones. l. 76.2 x w. 18 cm (30 x 7 in.). Founders Society Purchase (81.302).

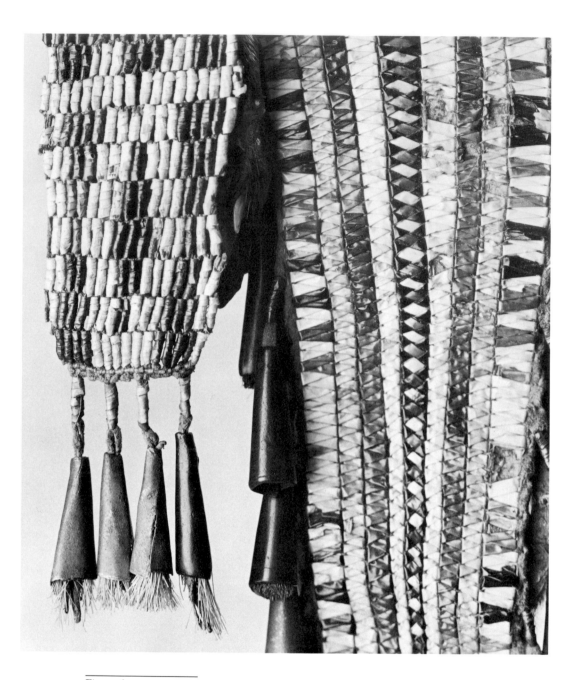

Figure 4.
Detail of *Midé Bag*
(Pinjigosaun), figure 3.

and Fox,[8] the Midéwiwin was largely
concerned with the pursuit of a good,
long, and healthy life. "The blessing of
life," the product of good, upright
living, was believed to derive from the
Midéwiwin. This blessing was gained by
the Ojibwa forebears with the aid of
"the Great Spirit," but was subse-
quently lost to later generations through
cultural upheaval.[9] To restore the people

to their favored state, and thus "pre-
serve the traditions" of Native heritage
and cosmology, was a central aim of the
Midéwiwin.[10]

Members and initiates of the Midéwiwin
society were instructed in the uses of
herbal remedies and medicines, hunting
charms, and spiritual powers, and
learned the history of their people as
well as Midéwiwin lore and song. The
Midéwiwin was structured into a series
of degrees, each with increasing levels of

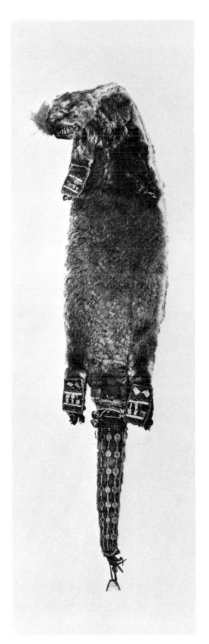

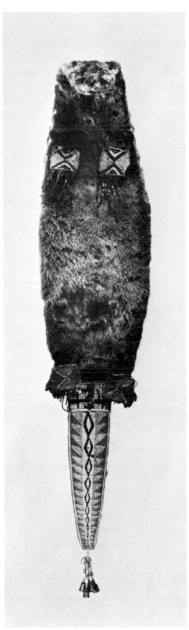

Figure 5.
Midé Bag (Pinjigosaun),
Potawatomi, c. 1860;
otter skin, quill
embroidery, wool,
feathers, leather fringe,
and brass-colored
thimble and bells, l. 87.6
x w. 15.5 cm (34½ x 6¼
in.). Founders Society
Purchase (81.462.1).

Figure 6.
Midé Bag (Pinjigosaun),
Potawatomi, c. 1850;
otter(?) skin, quillwork,
beads, brass thimbles,
and leather thongs, l.
129.5 x w. 23 cm (51 x 9
in.). Founders Society
Purchase (81.299).

power accorded to its members. The
number of degrees varied according to
local traditions, but usually consisted of
four or eight stages. A candidate was
initiated into the first degree, then
received further instruction, often
taking years to complete, before
advancing to the second level and
continuing up through the hierarchy.
The degrees reached by members varied
greatly, although it appears that many
candidates went at least as far as the
second level. Many were prevented from
obtaining the more advanced stages by
the high costs involved. It often took
years to repay loans of furs, goods, or
funds borrowed to underwrite the
necessary instruction and initiations.[11]

The pinjigosauns: form and content
Initiation into the Midéwiwin took
several days and included both private
and public ceremonies.[12] Following
initiation into each degree, the candi-
date received a pinjigosaun made from
an animal or bird skin. Each degree had

a "special sort of bag, which thus served as a distinctive badge showing the degree attained by its owner,"[13] with the otter associated with the medicine society's lowest rank.[14] Skins of mink or weasel, relatives of the otter, also have been used for the first degree bags. The following correlation of bag to degree has been proposed:

1st degree—otter
2nd degree—hawk
3rd degree—owl
4th degree—bear
5th degree—eagle
6th degree—wolverine
7th degree—lynx
8th degree—rattlesnake.[15]

In some instances, the actual type of bag used may have been related to a spirit seen by a member during a dream or vision. These vision spirits acted as personal guardians to those they visited. However, the consistency of form of the pinjigosauns suggests that only at the higher degrees did an individual consider using an image of his spirit guardian as his medicine bag. It has also been suggested that special bags were used by the Midéwiwin shaman who participated in a candidate's initiation; other observers have asserted that the choice of bag was an independent decision made by the initiates.[16]

Observers have indicated that the pinjigosaun contained "colors for facial ornamentation, and the magic red powder employed in the preparation of hunters' songs; effigies and other contrivances to prove to the incredulous the genuineness of Midé pretensions, sacred songs, amulets and other small manidos . . . invitation sticks, etc."[17] Another commentator has reported that they "contain[ed] all which he [a Midé member] holds most sacred . . . preserved with great care and seldom ever allowed in a place in the common wigwam, but . . . generally left hanging in the open air on a tree. . . . The contents were never displayed without ceremony."[18]

How the bags were originally acquired and later disposed of is an unresolved question. One Midéwiwin member was reported to say "this medicine bag has come to me from my grandfather, through my father."[19] However, another commentator claimed that medicine bags were the most valued possession and were usually buried with an individual.[20] Highly prized, many bags obviously were passed on from generation to generation as new members were initiated. The bags would have been used by Midé members every time they were called upon to administer medicines, which were often held in the pinjigosauns. Every member also would have had his bag with him at initiation and instructional ceremonies.

The pinjigosauns also played an important role in the initiation rituals themselves. The public initiation ceremony began when the candidate, accompanied by his instructor and an assistant, entered the midéwigan, or Grand Medicine Lodge. Entrance into the lodge meant the candidate was ready to receive the power of the Midéwiwin. The candidate moved to the center of the lodge and knelt on a blanket. Songs then were sung extolling the power of the megis, a small shell which, according to some legends, had guided the Ojibwa ancestors back to their homeland.[21] Each shaman held an otter pinjigosaun in his hands as if it were a rifle and "shot" a megis into the candidate. For a first degree initiation, the candidate was shot in the breast, heart, and head, while different parts of the body were fired upon during ceremonies for the higher degrees.[22]

After being shot, the candidate "died," collapsing lifeless on the ground. The priest then placed the pinjigosaun on the candidate's back and after a few moments a megis shell dropped from the initiate's mouth.[23] As the candidate began to revive, the megis was shown to everyone and replaced in his mouth. The candidate died again, only to be revived by the Midéwiwin members. Following this last revival, the candidate took "the drum from the head priest and chanted a song celebrating his acceptance to the society," distributed gifts and paid fees to other members, and received his own pinjigosaun.[24]

Among some groups, it was believed to be the megis that brought the essence of the Midéwiwin to the Ojibwa, rather

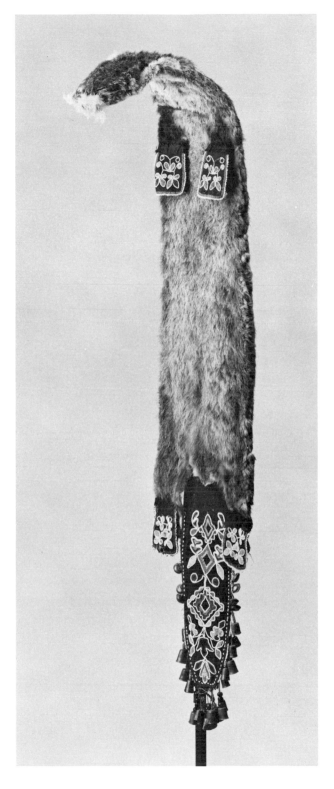

Figure 7.
Midé Bag (Pinjigosaun),
Potawatomi, c. 1880;
otter skin, beads, silk
ribbons, wool, cloth, and
brass bells and thimbles,
l. 110.5 x w. 24 cm
(43½ x 9½ in.).
Founders Society
Purchase (81.300).

than the otter. In the initiation
ceremony, during the enactment of the
transfer of Midéwiwin power, the candi-
date was always shot with a megis that
was contained in an otter pinjigosaun.
Thus, it was the otter that brought the
power of the Midéwiwin, either on its
own accord or as a carrier of the megis.

Ojibwa cosmology and the otter

The Ojibwa cosmos consisted of a
multiplicity of manitos, including the
otter, inhabiting "all space and every
conspicuous object in nature."[25] Manitos
were regarded with awe, affection, or
dread, depending on their place in the
hierarchy of power. They were believed
to live in three spheres: the sky (thought
to be a dome above the earth); the earth
(thought to be a flat island); and below
the earth (thought to be another flat
island).[26] The supreme power in this
hierarchy was referred to as Kitche
Manito, who was considered the "owner"
of the world, the most remote of all
beings, and generally divorced from any
phenomenal manifestation.[27] Thunder-
birds occupied the next level in the
hierarchy of power and generally were
thought to be the messengers of Kitche
Manito. Another group of very powerful
beings was the underwater manitos or
Underwater Panthers. These manitos
lived below the water, where they influ-
enced the abundance and availability of
both land and water animals and thus
were of great importance to the hunters.

The majority of manitos in which the
Ojibwa believed belonged to the group
called "owners." The otter was one of
many such manitos.[28] An owner or spir-
itual boss existed for all birds, beasts,
elemental forces, life circumstances such
as poverty and motherhood, trees, plants,
roots, the sun, the moon, thunder, light-
ning, the seasons, and mythical crea-
tures. Owners were never seen with the
naked eye and were usually the subject
of dreams. Initially there appears to be

89

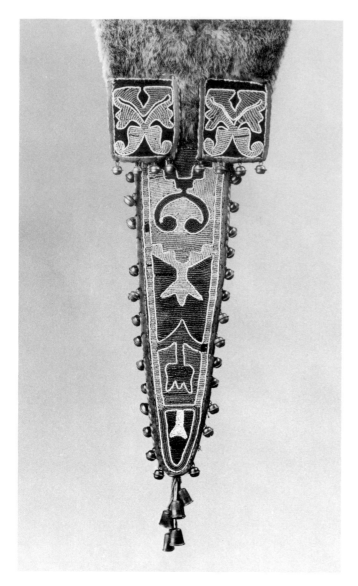

stretches of land and water.[29] The otter is equally at home in water and on the land: "its legs are short and strong for land travel, yet easily tucked to its sleek sides when swimming after fish or poking about on river bottoms."[30] In some Midéwiwin legends, the otter itself acts as the society's messenger.

The otter, often called the guardian of the first degree, brought a sense of joie de vivre, playfulness, and hope for happiness and continued life to the Midéwiwin. As Ojibwa legend makes clear, it was the laughter of the otter that attracted the attention of the culture hero Nanabozho. Recent animal behavioral studies have confirmed that the river otter does emit a "low keyed chuckling noise that seems to be associated with pleasant feelings while . . . communicating at close range," and that "the otter's greatest passion is play."[31]

Although life in the winter was hard for the Ojibwa, when the hunt was successful and there was food for another day there would be moments of fun and laughter. One of the games played by the Ojibwa involved the use of a small carved wooden otter. Wooden pieces in various shapes, including an otter, were thrown into the air and scoring was done on the basis of the positions in which they landed. This game was "preferred by the old men, especially those closely associated with the Grand Medicine Lodge."[32] In the same way that the otter brought good fortune and hope for life to the Ojibwa when he helped communicate the mysteries of the Midéwiwin, similarly the animal brought luck to gamblers.

In conclusion, it is clear that the otter filled an important function in the Midéwiwin. As a container for the medicines, paints, and other elements of power belonging to the shaman, the otter pinjigosaun functioned in the same way as the original otter of myth; in conveying the knowledge of the

very little to distinguish the otter from the great variety of other owner manitos in the Ojibwa world. Yet on closer inspection the otter can be seen to incorporate several characteristics integral to Ojibwa ideology and continuance that account for its prominence in the Midéwiwin.

In all myths concerning the Midéwiwin, the messenger who brings the rituals to the Ojibwa has the ability to travel over land and through water. Other Ojibwa legends tell of the group's own movement from the shores of the great sea, along a great river, and finally, to the shores of Lake Superior, a journey which would take them over great

Midéwiwin, it protected the essence of what it meant to be an Ojibwa. At the most elementary level of the Midéwiwin, the initiate encountered the otter. No matter which myth of origin was retold and whether or not it focused on the otter as messenger, the first-degree member would usually have been given an otter pinjigosaun. The significance of this usage is explained in a myth in which four Midéwiwin manitos appeared in the eastern sky "each carrying a live otter. . . . They used these otters as Midé bags are now used in ceremonies of the society . . . and by this means they restored life to the young man who had been dead eight days."[33]

On a symbolic level the otter partakes in the most basic element of Midéwiwin power, the ability to integrate the worlds that the Ojibwa see in opposition: that of the land and that of the water; that of

the traditional hunting bands and that of the European fur trader or settler. The Ojibwa were striving to lessen the tensions which abounded in the worlds that surrounded them, both in the spiritual world and the encroaching world of European civilization, and in the powers which exercised control over them. Just as the Ojibwa drew on the resources of both land and water to survive, so too the otter lived in both environments. For a people who had traveled over land and water to reach the area that was to become their home and had been subjected to the hardships and the rewards of both, a creature who moved through both with ease and playfulness was to be respected and revered. The otter as used in the Midéwiwin was one attempt to structure and retain the ideology of the Ojibwa ancestors in order to confirm the continued existence of this Native American group.

Notes

1.
W. Warren transcribes the term as "pin-jig-o-saun" *(The History of the Ojibway Nation*, Minneapolis, 1974 [orig. pub. 1885]: 68) while N. Perrot uses "pindikossan" ("Memoir on the Manners, Customs and Religion of the Savages of North America," in *The Indian Tribes of the Upper Mississippi Valley and Region of the Great Lakes*, ed. E. Blair, Cleveland, 1911: 50).

2.
Nanabozho is identified in the literature by several names: on Mi nabo zho, see W. J. Hoffman, "The Mide'Wiwin of the 'Grand Medicine Society' of the Ojibway," *Seventh Annual Report of the Bureau of American Ethnology 1885-1886* (1891): 166; on Ninabojo, Nanabush, Nanabojo, see F. Densmore, "Chippewa Customs," *Bureau of American Ethnology Bulletin* 86 (1929): 97.

3.
Hoffman 1891 (note 2): 166-167.

4.
For more on quillwork techniques, see J. Bebbington, *Quillwork of the Plains*, Calgary: The Glenbow Museum, 1982; and R. Odle, "Quill and Moosehair Work in the Great Lakes Region," in *The Art of the Great Lakes Indians*, Flint: Flint Institute of Arts, 1973.

5.
Bebbington 1982 (note 4): 41.

6.
Ibid.: 26 and 29.

7.
J. Harrison, "The Midéwiwin: The Retention of an Ideology," M.A. thesis, University of Calgary, 1982.

8.
H. Hickerson, "The Feast of the Dead Among the Seventeenth Century Algonkians of the Upper Great Lakes," *American Anthropologist* 62 (1960): 81-107.

9.
R. Landes, *Ojibwa Religion and the Midéwiwin*, London, 1968: 42; and Warren 1974 (note 1): 79.

10.
Hoffman 1891 (note 2): 151.

11.
As a result of the strict selection process in later years, the information generally restricted to the third and fourth degrees was often dispensed at the second degree to prevent the loss of information through the death of older members. See S. Dewdney, *The Sacred Scrolls of the Southern Ojibway*, Toronto, 1975: 88; and Hoffman 1891 (note 2): 202.

Landes, who identified eight degrees, felt that most people achieved the third or fourth degree. She describes the fifth to the eighth, or 'sky' degrees, as being "dangerous" and obtained by very few people (1968 [note 9]: 52).

12.
Landes 1968 (note 9): 72.

13.
Densmore 1929 (note 2): 93.

14.
W. J. Hoffman ("Pictography and Shamanistic Rites of the Ojibwa," *American Anthropologist* 1 [1888]: 220) suggests that the otter bag "symbolizes a spirit having the power to assume any desired form."

15.
F. Blessing, Jr., "The Ojibway Indians Observed," *Occasional Publications in Minnesota Anthropology* 1 (1977): 111.

16.
V. Kinietz, *Chippewa Village: The Story of Katikitegon*, Bloomfield Hills, Michigan: Cranbrook Institute of Science, 1947: 207.

17.
Hoffman 1891 (note 2): 220.

18.
Warren 1974 (note 1): 68.

19.
H. R. Schoolcraft, *Information Respecting the History, Condition and Prospects of the Indians of the United States*, 2, 5, Philadelphia, 1860: 430.

20.
Densmore 1929 (note 2): 93.

21.
On the megis, see Hoffman 1891 (note 2): 183-184.

22.
Ibid.: 265.

23.
Ibid.: 215.

24.
D. Jenness, "The Ojibwa Indians of Parry Island, Their Social and Religious Life," *Bulletin of the National Museum of Canada*, Anthropological Series 78 (1935): 73.

25.
Hoffman 1891 (note 2): 163.

26.
C. T. Vecsey, "Traditional Ojibwa Religion and Its Historial Changes," Ph.D. dissertation, Northwestern University, 1977: 78-79.

27.
A. I. Hallowell, "Some Empirical Aspects of Northern Saulteaux Religion," *American Anthropologist* 36 (1934): 390-392.

28.
Ibid.: 391.

29.
Warren 1974 (note 1): 81.

30.
D. Haley, *Sleek and Savage: North America's Weasel Family*, Seattle, 1975: 106-107.

31.
Ibid.: 109-110.

32.
Blessing 1977 (note 15): 51.

33.
Densmore 1929 (note 2): 93.

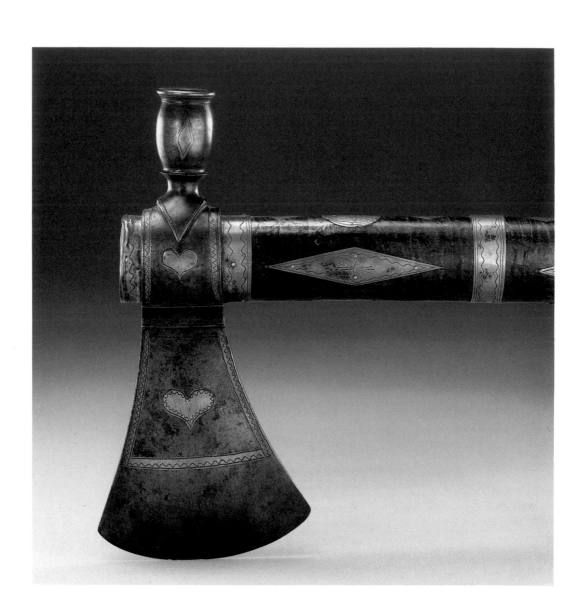

Pipe Tomahawks from Michigan and the Great Lakes Area

Richard A. Pohrt

Tools and weapons in great variety were developed by Europeans during their years of exploration and conquest in North America. Many of these items, offered in exchange for furs and other native products, found their way into Indian hands as trade goods. The pipe tomahawk, however, was a unique North American implement, combining an ax with a smoking pipe. Two *Pipe Tomahawks* (figs. 1, 11, 2, and 3) in the collection of the Detroit Institute of Arts are among the finest of their type and represent the culmination of a tradition that involves European and American manufacture and Native American craftsmanship and culture.

The North American Indians' desire for iron and steel tools resulted in the importation of great quantities of axes, hatchets, and knives into the eastern portion of the continent from Europe. The first iron axes traded by European explorers to the native people of the New World were large, heavy felling axes of the type used by woodsmen or ships' carpenters. In some instances their application and use were not understood by the indigenous population. Indians of the Hudson River Valley thought that both axes and hoes were objects of adornment to be hung around the neck.

Figure 1 (opposite).
Pipe Tomahawk, Miami (Indiana), 18th century; wrought iron, steel, silver inlays, and maple, 59.7 x 20.3 cm (23½ x 8 in.). Founders Society Purchase with funds from Flint Ink Corporation (81.205).

Figures 2 and 3.
Pipe Tomahawk, Potawatomi (Ohio), c. 1820; wrought iron, steel, silver and lead inlays, and hickory, 46.7 x 17.2 cm (18⅜ x 6¾ in.). Founders Society Purchase with funds from Flint Ink Corporation (81.204).

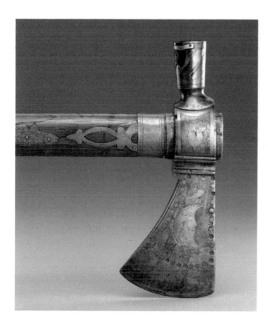
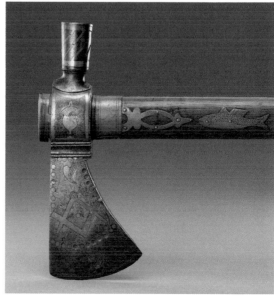

John Heckewelder, an eighteenth-century Moravian missionary, reported that this occurred amongst the Delaware, who "knew not the use of the axes and hoes . . . given them the year before; for they had these hanging to their breasts as ornaments."[1] It was necessary for the traders to show the Indians how to fashion handles and provide instruction in the tools' proper use. The Indian was quick to realize the advantages of a light hatchet as an efficient combat weapon. Adriaen Van der Donck, who negotiated a treaty between the Dutch and the Mohawk Indians, reported as early as 1656 on Indians in the vicinity of New York: "at present they also use small axes (tomahawks) instead of their war clubs."[2] Robert Livingston, an early New York settler and later a secretary of Indian affairs for the colony, recounted the details of a battle between the French and Iroquois in 1687: "the French retired about 150 paces and stood still, the Sinnekes (Iroquois) continued the fight with their hatchets."[3] These early hatchets, standard woodcutting tools, were designed and manufactured in Europe or made by colonial blacksmiths. Smaller than an ax and fairly light in weight, they were ideally suited for the Indians' needs as a camp tool or a combat weapon. This simple wood-cutters' tool was the prototype for the tomahawk, a humble beginning for what eventually developed into a unique American weapon.

Early accounts dealing with Indian life, the fur trade, or combat on the frontier are generally not specific when using the word tomahawk. Derived from the language of the Virginia Algonquian, the term originally described a weapon of war. In seventeenth- or eighteenth-century usage, however, it is difficult to determine whether an author was indicating a tool or weapon. A variety of native stone implements and wooden hand weapons are occasionally referred to as tomahawks, further complicating the problem.

A fresh attempt to define the word tomahawk is in order and the following definition is suggested: a weapon with a metal blade, usually iron or steel, hatchet-like in form, and designed or decorated in such a manner as to be distinguishable from a common hatchet. Tomahawks, whether undecorated or ornate, exhibit a refinement and finish not generally extended to the ordinary hatchet of the time.

Origins of the pipe tomahawk
It is not certain when the pipe tomahawk was first introduced, but it appears to have been sometime during the first half of the eighteenth century. Lieutenant Henry Timberlake observed and described pipe tomahawks among the Cherokee in the 1750s.[4] There is a strong possibility that the pipe tomahawk was first manufactured by a blacksmith in America. Hand-forged iron pipe bowls, which were used for smoking, are occasionally found at old camp grounds and village sites. These iron pipe bowls were forged by the same men who were making and repairing axes and hatchets, and it seems likely that an alert blacksmith recognized the advantages of bringing the two objects together.

We also cannot discount the possibility that an Indian, who was familiar with metal working or serving as an apprentice to a blacksmith, first engineered the pipe tomahawk. An early reference to the Indians' acquaintance with blacksmithing is found in the writings of the Moravian missionary David Zeisberger, who noted in 1779-80, "some who have been much with whites have begun to work in iron, have fashioned hatchets, axes, etc., right well, have given up the chase because they have found regular work much more profitable and less hard on clothing and shoes than wandering through the forest in pursuit of game."[5] In addition, the most common material used by Indians for a pipe stem was an ash sapling. This was the same material used for the handles of hatchets and tomahawks. It seems but a short step for an Indian, patiently fitting a handle in a hatchet head, to realize that he had the makings of a pipe stem. The addition of a pipe bowl to the poll, or back, of his hatchet blade would produce a dual purpose object — one that could be used for chopping or smoking.

Although some pipe tomahawks were made in England and exported to North America, it appears that the majority

96

Figure 4.
Pipe Tomahawk, Allen
County, Ohio, c. 1790;
wrought iron and steel,
17.5 x 5.5 cm (6⅞ x 2³⁄₁₆
in.). Collection of
Richard A. Pohrt.

Figure 5.
Pipe Tomahawk,
Northern Ohio, c. 1775;
wrought iron, steel, and
brass, 18.5 x 5 cm (7⁵⁄₁₆ x
1¹⁵⁄₁₆ in.). Collection of
Richard A. Pohrt.

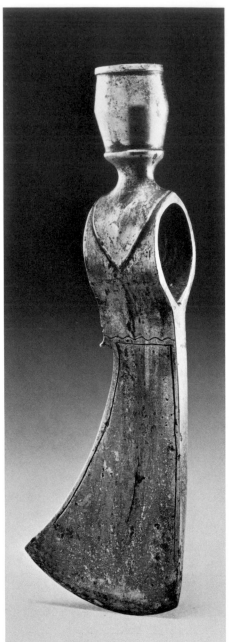

Figure 6.
Pipe Tomahawk,
Northern Ohio, c. 1775;
wrought iron and steel,
22 x 6.5 cm (8$^{11}/_{16}$ x 2$^{9}/_{16}$
in.). Collection of
Richard A. Pohrt.

Figure 7.
Pipe Tomahawk, Elgin
County, Ontario,
Canada, c. 1800;
wrought iron and steel,
17.5 x 6 cm (6$^{7}/_{8}$ x 2$^{3}/_{8}$
in.). Collection of
Richard A. Pohrt.

were made in America by rural black-smiths. Most tomahawks show a great variety in design, size, and decorative detail, and lack the standardization usually associated with quantity production. In addition, it is very rare for a pipe tomahawk to be stamped with the maker's name or trademark, a practice which was common among English manufacturers. The frequent use of scrap iron, especially from damaged musket and rifle barrels, contributed to the wide variation in tomahawk styles. Early examples, dating from the late eighteenth century, were made in the same manner as a hatchet, with the pipe bowl attached to the back of the blade. Several methods were used to attach the bowl, and all demonstrate the ease with which a common hatchet could be converted to a pipe tomahawk. Of special interest is the method of attaching the unusual octagonal pipe bowl to the *Tomahawk* (fig. 4) of about 1790 from Allen County, Ohio. As with most toma-hawks, the blade is wrought iron with a steel cutting edge. The bowl was forged from a tubular piece of wrought iron, probably from an old musket barrel. A slot was cut in the poll and the bowl was slipped, or keyed, into place before being soldered, or brazed, to the blade. A *Pipe Tomahawk* (fig. 5) with a screw-in bowl suggests another possible early method of creating this implement. The blade was made from a single strip of wrought iron that was bent into a U shape. A steel bit, used for the cutting edge, was positioned between the arms of the U, which were then forge-welded together to hold the bit securely in place. An opening, or eye, was left for the handle. A hole was drilled through the poll and threaded. A brass bowl,

threaded at the base, then was screwed in to complete the object.

Later, pipe tomahawks were forged from a single piece of iron so that the pipe bowl became an integral part of the blade. One such *Pipe Tomahawk* (fig. 6) displays a hand-forged bowl that is similar in shape to some early stone pipe bowls found in northern Ohio and Michigan. The blade has a steel cutting edge, in this case inserted into the wrought iron and welded in place. Steel, a scarce commodity, provided a more serviceable cutting edge than the wrought iron, which could not be hardened to hold a sharp edge. A wrought iron blade would have required sharpening each time it was used and would have been completely worn away after a short period of time. The blade itself is decorated with zigzag lines along the top and bottom edges. The blade was pierced to form the eye for the handle.

A *Pipe Tomahawk* (fig. 7) from Elgin County, Ontario, dating from about 1800, was made from a section of a scrap musket barrel, with a steel cutting edge added to the blade. The blade has a pierced eye and was hand finished and decorated with traces of engraving. The top edge of the blade turns down slightly, producing an attractive curving form. The barrel-shaped bowl is similar to those used on later tomahawks from

Figure 8.
Pipe Tomahawk, Great Lakes, c. 1775; wrought iron and steel, 23 x 7.5 cm (9 1/16 x 2 15/16 in.). Collection of Richard A. Pohrt.

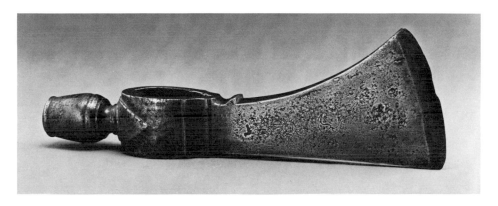

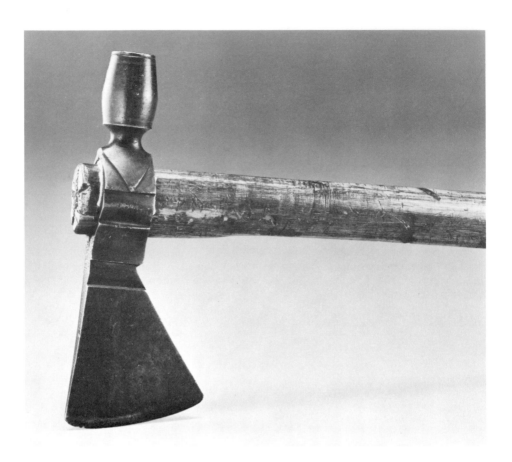

Figure 9.
Joseph Jourdain,
American, *Pipe
Tomahawk*, c. 1800-1825;
wrought iron, copper,
and ash, 17 x 7 cm (6¹¹⁄₁₆
x 2¾ in.), length of
handle 57 cm (22⁷⁄₁₆ in.).
Collection of Richard A.
Pohrt.

the western Prairies and Plains. Often-
times the marks inside of a pipe bowl or
eye correspond with the damaged
threads or rifling inside a musket or
rifle barrel.

Common weapon types

Two types of pipe tomahawk commonly
found in Michigan and the surrounding
Great Lakes area are so similar in size,
shape, and decorative detail as to suggest
mass production. These standardized
pipe tomahawks were probably manu-
factured by English blacksmiths and
exported to this country for use as trade
goods with the Indians. One type (see
fig. 8) is so common in Michigan collec-
tions that it far outnumbers all others. It
is a large, rugged tomahawk constructed

from three pieces of wrought iron with
an added steel cutting edge and features
a series of decorative marks stamped
into the blade's surface. The body of the
blade was made in the same manner as
an ax or hatchet. A hollow tube then
was welded over a stud riveted to the
blade's poll to form the pipe bowl. The
lightly impressed designs depict a bird
with the letter E, a sun, a quarter moon
with a face, and seven six-pointed stars.

The second commonly found variety of
pipe tomahawk (see fig. 10) features a
blade cast in brass, a steel cutting edge,
an acorn-shaped bowl, and engraved
decoration. Although the steel bit
appears to be keyed to the blade, the
brass was actually cast around and over
part of the cutting edge to insure a
stronger bond. While this type of toma-
hawk was pleasing in appearance, it was
a fragile piece of equipment and easily
broken. Distributed over a wide area of
the Great Lakes region, its popularity
was short lived.

Tomahawk blades usually were supplied
without handles, forcing the Indians to

fashion their own. On occasion the entire unit, handle and blade, were manufactured by whites. The Indians crafted their handles from a sapling, usually ash, slightly larger in diameter than the intended finished piece. The heart of the sapling was burned out with a hot wire to produce the hole through which the smoke passed, the same method used to make a traditional pipe stem. The handle was worked down to size and fitted through the top of the blade. The upper end of the handle was left slightly larger than the bottom to fit the shape of the eye, which was also larger at the top. This design prevented the handle from being pulled all the way through the tomahawk and kept the blade from flying off the handle when the implement was in use. Due to the rough interior surface of the eye of the blade, it was difficult to fit a handle tightly enough to prevent the leakage of air when the pipe was smoked. To overcome this problem a buckskin gasket was placed inside the eye between the handle and the blade. This also made it possible to compensate for shrinkage of the handle due to changes in the weather. Those handles manufactured by white craftsmen were constructed slightly differently. Whites used milled lumber, such as oak or maple, instead of a sapling, and the smoke hole was drilled instead of burned through the wood.

Figure 10.
Pipe Tomahawk,
Southern Michigan,
c. 1805; brass and steel,
1. 18.7 cm (7⅜ in.).
Formerly Collection of
Richard A. Pohrt.

Presentation pipes

Ornate pipe tomahawks were made for presentation to Indian leaders on special occasions, such as treaty signings, or as expressions of personal esteem. Such tomahawks display superior craftsmanship, featuring silver or brass inlays, engraved iron and steel blades, and handles of selected hardwoods. Frequently the name of the donor or recipient and the date of the gift is engraved on the metal inlays. Both presentation pipes in the Detroit Institute of Arts were originally collected by Milford G. Chandler. Chandler obtained the first example (figs. 1 and 11) from Camellius Bundy, a Miami Indian from Peru, Indiana, in the early 1920s. Bundy was a direct descendant of Frances Slocum, a white woman captured by Delaware Indians in 1778. She later married the Miami chief Deaf Man, or She-buk-o-nah, and settled in a Miami village on the Wabash near Peru in about 1810. According to Bundy, this tomahawk originally belonged to the Deaf Man. The Bundy family believed that the tomahawk had been presented to the Miami by General Anthony Wayne at the signing of the Treaty of Greenville, Ohio, in 1795.[6] The blade, forged from a single piece of wrought iron, has a steel cutting edge and an oval-shaped eye. It is decorated with inlaid silver hearts and diamonds. A delicate border of inlaid silver follows the curves of the blade's top and bottom edges and surrounds the hearts. The handle is made of curly maple with a drilled smoke hole and also features inlaid silver decorations. Thin sheets of silver were cut into diamond and circle shapes and affixed to the dark brown wood with small

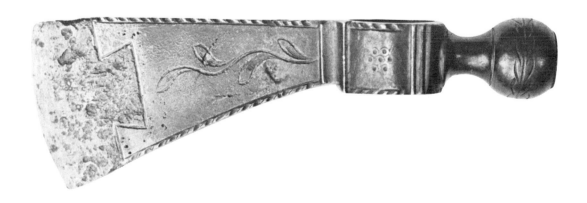

silver pins. Each grouping of diamond and circle is separated from the next by a narrow band of silver. A silver cap and a mouthpiece for smoking grace the two ends of the handle. All of the inlaid silver, on both handle and blade, is decorated further with engraved lines and patterns. There is no inscription on this object.[7]

The other presentation *Pipe Tomahawk* (figs. 2 and 3) in the museum's collection dates from about 1820 and was purchased by Chandler in Covington, Kentucky, in the early 1920s. The blade, made from a solid piece of wrought iron with a steel cutting edge and a pierced eye, is decorated with a number of silver inlays. The square and compass, a symbol of the Masonic fraternal order to which some Indians belonged, and a heart are on one side; a heart and quarter moon

with a face are on the other. The round tapered pipe bowl is decorated with thin inlaid bands of silver that wind their way diagonally across the surface. The handle is made of hickory and has a drilled smoke hole. Silver inlaid fish, acorns, and circular bands decorate the handle in a fashion reminiscent of the inlays found on Pennsylvania rifles of the period. Fins and scales are engraved on the fish, and the acorns are shaded with a fine engraved cross-hatching. Lead was cast under the blade to secure it to the handle and the same material was inlaid at the mouthpiece. A silver inlay at the top edge of the blade is engraved with the name Ottokee, indicating the probable owner of the tomahawk. Ottokee was a prominent Potawatomi Indian in the Maumee River Valley during the early 1820s.

Figure 11.
Pipe Tomahawk, Miami (Indiana), 18th century; wrought iron, steel, silver inlays, and maple, 59.7 x 20.3 cm (23½ x 8 in.). Founders Society Purchase with funds from Flint Ink Corporation (81.205).

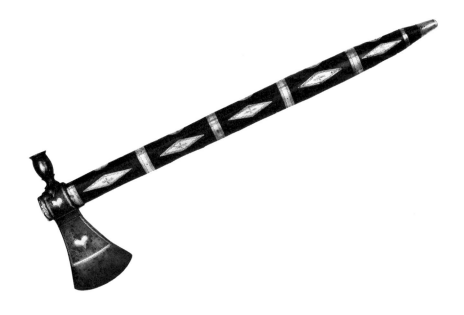

With the end of the War of 1812, Michigan Indians and most of the tribes of the Great Lakes area never fought again as independent people in defense of their land and homes. The war marked not only the end of tribal warfare but the finish of the Native Americans' participation as allies in the European struggles for domination in the New World as well. When Michigan Indians next went into battle, it was as individual volunteers in the Union Army in the 1860s. While blacksmiths in Illinois, Michigan, and Wisconsin continued to make pipe tomahawks, it was for an ever-decreasing clientele. A *Pipe Tomahawk* (fig. 9) manufactured by Joseph Jourdain, a blacksmith from Green Bay, Wisconsin, is typical of these later types of tomahawks. The barrel-shaped bowl, the size and shape of the eye, and the decorative details all are representative of Jourdain's fine workmanship. The tomahawk was forged from a section of scrap musket barrel and has a pierced eye and an ash handle. A copper inlay of a quarter moon appears on the blade and narrow inlaid decorative bands encircle the pipe bowl.

As the Great Lakes Indians attempted to adjust to a more settled and restricted way of life, weapons of war were supplanted by implements of a more peaceful existence. Still, for many years, pipe tomahawks continued to be seen at tribal celebrations. Carried with pride and dignity by elderly warriors, the old combination weapon and pipe was a symbol of past glories. The pipe tomahawk, a weapon associated with close hand-to-hand combat, was no longer needed and had become a mere curiosity of a bygone time.

Notes

1.
John Heckewelder, *History, Manners, and Customs of the Indian Nations Who Once Inhabited Pennsylvania and the Neighboring States*, New York, 1971: 74.

2.
Arthur Woodward, "The Metal Tomahawk: Its Evolution and Distribution in North America," *The Bulletin of the Fort Ticonderoga Museum* 3, 3 (1946): 4.

3.
Ibid.: 5.

4.
Ibid.: 13.

5.
David Zeisberger, *A History of the Indians*, Ohio Archaeological and Historical Publications, vol. 19, 1910: 21.

6.
Personal communication with Milford G. Chandler, 1958.

7.
Two other ornamented pipe tomahawks, so similar to the Miami tomahawk in all their detail as to suggest they were produced by the same maker, are known to exist. One is in the collection of the Museum of the American Indian, Heye Foundation, New York (14/5983), and is also from the Miami. The second is owned by Cranbrook Institute of Science, Bloomfield Hills, Michigan, and was acquired from Milford G. Chandler, who purchased it from a collector in Covington, Kentucky, in about 1922. Its tribal association is not known.

Index

Pages on which illustrations appear are in *italics*.